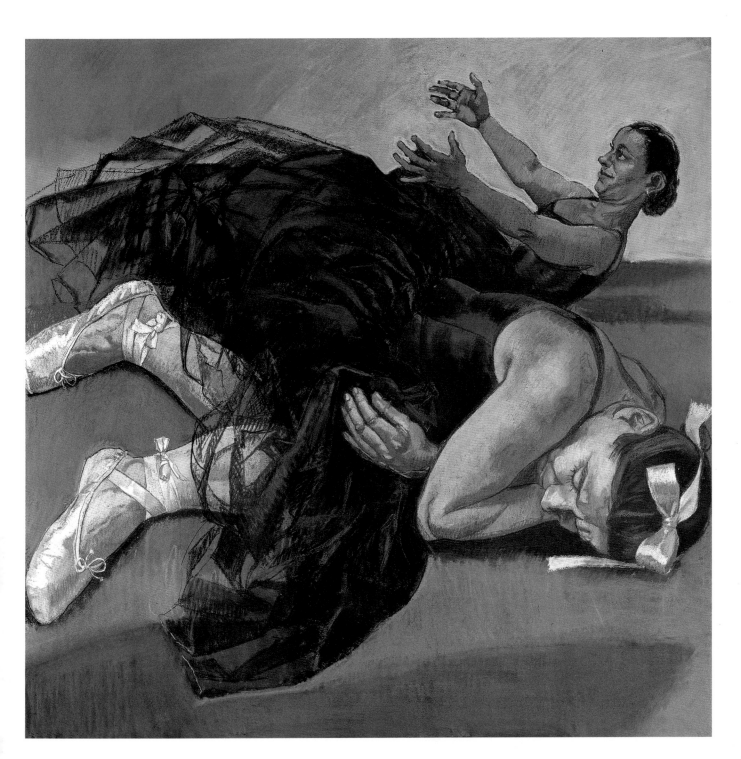

MODERN ARTISTS

First published 2002 by order of the Tate Trustees
by Tate Publishing, a division of Tate Enterprises Ltd,
Millbank, London SW1P4RG
www.tate.org.uk
© Tate 2002

British Library Cataloguing in Publication Data
A catalogue record for this book is available from the
British Library
ISBN 1 85437 388 9 (pbk)
Distributed in the United States and Canada by
Harry N. Abrams, Inc., New York
Library of Congress Cataloging in Publication Data
Library of Congress Control Number: 2002112232
Designed by UNA (London) Designers
Printed in Singapore

Front cover (detail) and previous page:
DANCING OSTRICHES FROM WALT DISNEY'S 'FANTASIA'
1995 (fig.65)
Overleaf: THE ARTIST IN HER STUDIO 1993 (detail, fig.51)
Measurements of artworks are given in centimetres, height
before width, followed by inches in brackets

Author's acknowedgements

This book is the result of a close working relationship with
Paula Rego, established at the time of her retrospective at
Tate Gallery Liverpool in 1997, and sustained through regu-
lar meetings at her studio ever since. Conversations about
life and work, and close analysis of work in progress form
the basis for much of the book, and I owe the artist a
tremendous debt of gratitude for the time she has given to
the project. The book incorporates material from some
previous essays on Rego's work, particularly 'Automatic
Narrative' in the catalogue for the exhibition at Tate Gallery
Liverpool and 'Recent Works' in Celestina's House, the cata-
logue for Rego's exhibition at Abbot Hall Art Gallery,
Kendal.

Thanks are due to several people. Firstly, John McEwen,
whose authoritative biography of the artist, published in
1992 and revised in 1997, is a starting point for anyone
considering her work. Thanks also to Sophie Allen, Felix
Barley, Nick Barley, Lewis Biggs, Celia Clear, John Erle Drax,
Sue Hopper, Silke Klinnert, Melissa Larner, Sophie
Lawrence, Gill Metcalfe and Mary Richards.

The book was written in Appledore in the summer of 2001.

Artists' acknowledgements

Paula Rego would like to thank The Gulbenkian Foundation,
Lisbon; Marlborough Fine Art, London; John Mills; The
National Gallery, London; Lila Nunes; Anthony Rudolf;
Caroline, Victoria and Nicholas Willing.

PAULA REGO

Fiona Bradley

Tate Publishing

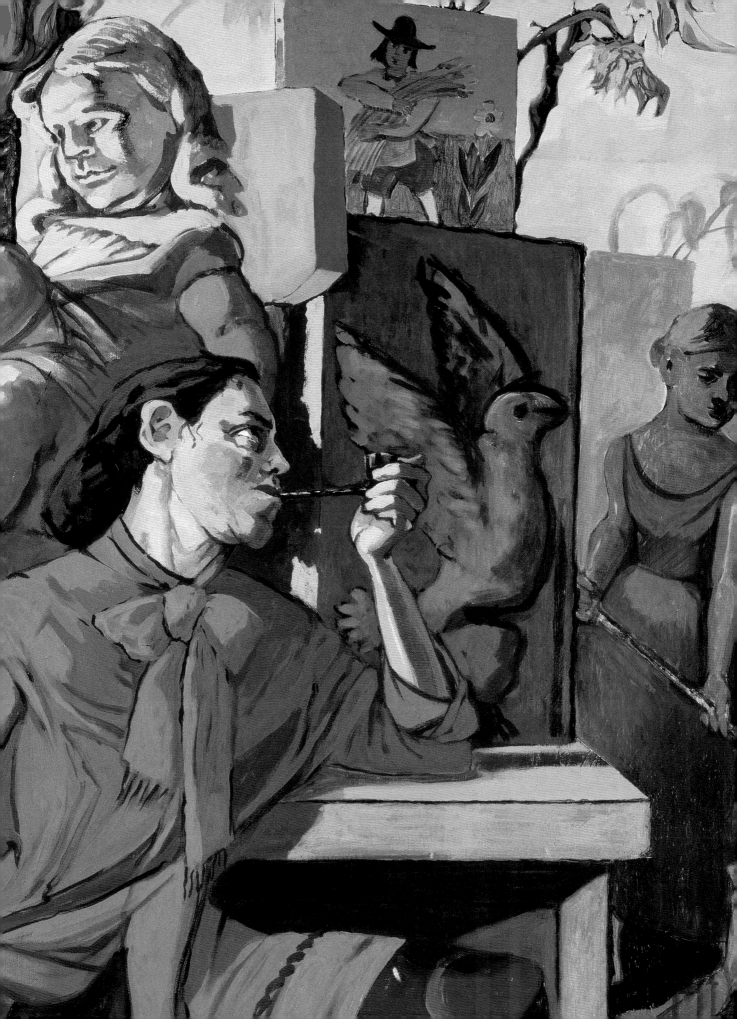

Paula Rego's favourite painting is Max Ernst's *The Virgin Spanking the Infant Jesus in Front of Three Witnesses (AB, PE and the Artist)* of 1926 (fig.1). An image of a large, haloed woman seated in a walled courtyard, her arm raised in anger over the bottom of her naked, determinedly un-haloed child, the painting was made in the context of Surrealist anti-clericalism, and on the territory of an earlier painting, Parmigianino's Mannerist *The Madonna with the Long Neck* of *c.*1532. Ernst subverts Parmigianino's subject and parodies his style. At the same time, he uses the painting to declare his Surrealist credentials (the two faces that share the witness box with him belong to André Breton, founder and leader of the movement, and Paul Eluard, one of its principal poets) and his antipathy towards the Catholic church. This antipathy is expressed in a classically Surrealist manner: Ernst perverts familiar Catholic iconography, insisting on the ordinary humanity and even the sexuality of the holy protagonists. As Mary hits her child she becomes, in the eyes of Ernst and the viewer, a good deal more of a mother than a virgin.

Rego likes this image for many reasons. Sympathetic with Surrealism's central ambition to understand and communicate inner dreams and desires, and excited by its determination to erode all boundaries and break all taboos in the process, she is familiar with the movement's pictorial techniques and conceptual strategies. Ernst's painting works as well as it does because he begins with a well-known situation. As viewers, we understand what he has done to the Virgin and Child because we are aware of what he ought more properly to have done with them. Although he claims the invention of the inverted, chastised child as his own, ostentatiously signing his name inside the errant halo, Ernst locates the actual blasphemy of the picture within the mind of the viewer rather than himself. By recognising the offending mother as the Blessed Virgin, it is the viewer who commits the cardinal sin.

Rego is best known for her large-scale, narrative paintings, many of which, like Ernst's, occupy familiar territory in their quest to involve the viewer in the telling of their tales. Like Ernst, she does not simply illustrate a story or a situation, but rather sets it up in such a way that she may connect with it in the manner best suited to her purpose – directly, tangentially, through juxtaposition, inversion or subversion, playing with both the expected and the unexpected. Her sources are wide-ranging, and she invents as well as adopting and adapting pre-existing scenarios, creating painted versions in which she and the viewer can move around at will. She collects stories from her own and from other people's lives; from books, films and paintings; from myths, legends and beliefs. She plunders the collective imagination in order to give it an individual twist. Concerned that the stories and the characters who inhabit and inform her works are strong enough to stand up to her treatment of them, she is often drawn to seemingly unassailable subjects, those so well-known or so well-resolved that, whatever she finds she has to do to them, she may be confident that they will fight back.

In a career spanning five decades, Rego has worked with characters from Peter Pan to Mary Magdalene, and with emotions from love to despair. Her technique has ranged equally widely, from collage and constantly mutating forms to a figurative realism where closely observed characters drawn from life are combined with a deliberate disregard for the conventions of scale or linear time. Rego has never cared for abstraction, but does believe in making the viewer work hard – whether to discern the hidden meaning of a tortured form, or to unearth the truth within a

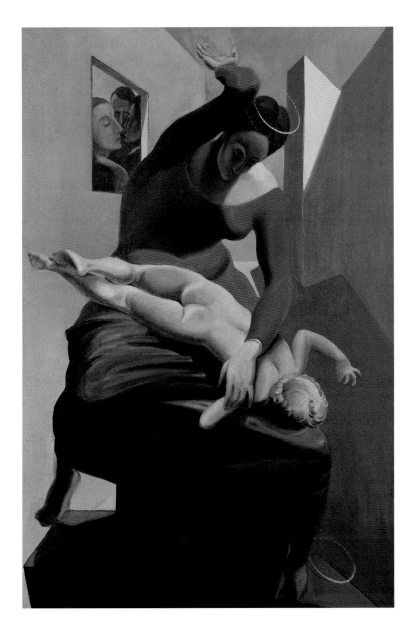

bewildering array of personal and narrative options. Ambiguity structures her painting, and while she obligingly begins stories for us, setting out scenarios and inventing or presenting characters, it remains always up to us to finish them off as we think best.

This book outlines Rego's life and work, running chronologically through her career and pictorial concerns. Several works are discussed separately, as key moments in the development of her practice, and as exemplars of her methods. These discussions are heavily dependent on the artist's own assessment of the works, and draw on material from recent interviews. The book also includes an essay looking in more detail at one particular aspect of Rego's work: the delight in the antisocial that unites much of her apparently disparate subject matter.

Rego's work is impatient to be looked at. A prolific artist, she is continually on the move, thinking through new ideas in new stories, and painting entire new cycles of work just as you might think it is time for her to take a break. The paintings themselves do not stand still either – dependent as they are on the viewer for their narrative completion, they change according to the new contexts in which they are seen. Often, it is the characters in the paintings who take control, as we recognise and mis-recognise them, interpreting them according to our own view of what we would like each painting to be about.

UNDER MILKWOOD 1954 [2]
Oil on canvas
110 x 110 (43 $\frac{1}{4}$ x 43 $\frac{1}{4}$)
Slade School of Fine Art, University
of London

CELEBRATION (THE BIRTHDAY
PARTY) 1953 [3]
Oil on canvas
124 x 205 (48 7/8 x 80 3/4)
Collection of the artist

EARLY WORK

Paula Rego was born Maria Paula Figueiroa Rego on 26 January 1935 in Lisbon, the only child of middle-class Portuguese parents. Her father was an electronics engineer who later owned a factory making precision instruments. The family was Republican and liberal, and had both English and French connections: Rego's father was an anglophile while her mother had been brought up in the Portuguese-French tradition of the well-to-do. Portugal was at the time under the dictatorship of António de Oliveira Salazar, who had become Prime Minister in 1932, and ruled as the self-appointed leader of the country until the Revolution of 1974. His government was in sympathy with Hitler's Germany.

Rego's father encouraged his daughter's early interest in art, buying her Alfred Barr's *Fantastic Art: Dada and Surrealism*, an important inspiration, for her fourteenth birthday, and supporting her application to art school in England. She studied at the Slade School of Art in London from 1952 to 1956. The school, run by William Coldstream, was extremely fashionable at the time, and Rego's peers included Craigie Aitchison, Michael Andrews, Euan Uglow and her future husband Victor Willing.

The teaching at the Slade in the early 1950s was centred on life-drawing and painting from the model. Once a year, the students were set a 'summer composition', a chance to make an imaginative painting on a theme set by the tutors. Two of Rego's survive: *Celebration* 1953 (fig.3), a scene of gluttony and gusto taking place round a large table, and *Under Milkwood* 1954 (fig.2), set somewhat incongruously in a Portuguese kitchen. Both paintings teem with observed anecdote and incident, their characters larger-than-life, players in a story told by the artist. The spaces they inhabit are, in contrast to the minutely-observed, if uneventful, real spaces of Rego's concurrent figure

studies, purely pictorial. Flat and rhythmically designed as well as swiftly painted, the two summer composition paintings pile shapes up the canvas, stacking forms one above the other, with little recession into depth. There are no shadows – these are purely spaces of the imagination.

These student paintings, far away from Rego's current practice though they may seem, nevertheless hold hints of her future concerns. There is an unwholesomeness about the drooping flesh in *Life Painting*, also made in 1954 (fig.4), which seems familiar, as are the prop- and relationship-based narratives of the two imaginative compositions.

Rego left the Slade in 1956, by which time she had met and, somewhat scandalously, fallen in love with Victor Willing, who was married at the time. Willing and Rego married in 1959, and moved together to Portugal, although they continued to travel back and forward to London, where Rego had a studio in Charlotte Street. They had three children – Caroline in 1956, Victoria in 1959 and Nicholas in 1961. On leaving the Slade, Rego found herself initially somewhat stuck, knowing she wanted to rid herself of the formal academicism taught at the school, but not quite knowing what to put in its place. In 1959, while on a visit to London, she saw an exhibition of the work of Jean Dubuffet, which was a revelation. Dubuffet's child-like aesthetic and raw, painterly immediacy showed her a way to get back in touch with the direct, almost visceral relationship with paint and painting she remembered from childhood, but which had been taught out of her at art school.

At the Slade, Rego had painted from life, using an easel, a working method which inevitably establishes a particular relationship between the body of the artist and the subject of the painting. Easel painting has a certain considered formality, a separation of the

LIFE PAINTING 1954 [4]
Oil on canvas
75 x 55 (29 1/2 x 21 5/8)
Collection of the artist

artist's body and the canvas. The work Rego began on leaving was quite different. Encouraged by Willing, who bought her copies of Dubuffet's periodical *Cahiers d'art brut*, she began to draw obsessively, working flat on the floor or on a table, holding the paper in her hands, her whole body engaged in the work. Drawing has always been important for Rego – she returns to it whenever she feels she has run out of ideas – and in Portugal she used it to free herself from the Slade. Delving into the picture plane and revelling in the materiality first of line then of colour, she started to paint with a powerful immediacy, making and remaking visual stories brimming with pictorial and corporeal incident.

Many of the paintings Rego made at this time have personal references embedded within them, often revealed, as in *Travelling Circus* 1960 (fig.5), in their relationship to the female body. The paintings differ violently from the studies and scenes of her work at the Slade, but although they may seem hard to read, they are never abstract. Rather Rego builds within them a vocabulary of forms, recognisable first in the positions they take up with reference to one another and to the picture plane within each individual painting, and then from one painting to another.

Rego plundered her mind and immediate experience for the material for these pictures – often twice. Having first drawn and painted sequences of forms – people, creatures, natural and unnatural elements – she then began cutting them up, radically altering their appearance before pasting them into a picture and pushing them around within it, painting afresh both around and on top of them. The artist has spoken of the physical and intellectual pleasure she derived from this cycle of creation, destruction and recreation, dwelling particularly on the close relationship between doing violence to a form and bringing it into

being. An interest in the potential for change represented by both physical and intellectual cruelty runs throughout her work.

Popular Proverb 1961 (fig.6) is unusual within Rego's work at this time, in that it is a more conventional kind of collage than those just described, in which all the source material was originated by Rego herself. The collage mechanism at work in *Popular Proverb* is reminiscent of that developed in Cubism, dada and Surrealism, in which elements from the real world are incorporated into a picture to extend its references. Most reminiscent perhaps of the dada collages of Kurt Schwitters, *Popular Proverb* constructs most of its creatures out of newsprint, the text of which remains just visible to set the picture firmly in the context of contemporary Portugal. It is a Portugal both personal and political – the picture contains within it references to stories Rego was told by her grandparents when she was little (it shows a boy trying to climb an apple tree while a dog bites his bottom), while the newspaper cuttings bring in actual, real-life events, and the large initials 'FR' may be a reference to Spain's General Franco, another of Salazar's dubious allies.

It was not possible to live in Portugal in the 1960s without taking account of the political and cultural realities of Salazar's dictatorship, and much of Rego's work at the time mixes the political with the personal in this way, a tactic to which she has returned at specific moments throughout her career, usually in response to events in Portugal. Some of her most powerful paintings of the period make reference to Salazar, whether in the writhing, fragmented forms of *Salazar Vomiting the Homeland* 1960 (fig.90, p.117), or in the multiple mutilations and narrative complexities of *When we had a House in the Country* 1961 (fig.7, p.12), an anti-colonial picture whose title Rego

TRAVELLING CIRCUS 1960 [5] top
Oil on paper
22 x 35 (8 5/8 x 13 3/4)
Collection of the artist

POPULAR PROVERB 1961 [6]
Oil and collage on canvas
49 x 123.5 (19 5/8 x 48 5/8)
Private Collection, Portugal

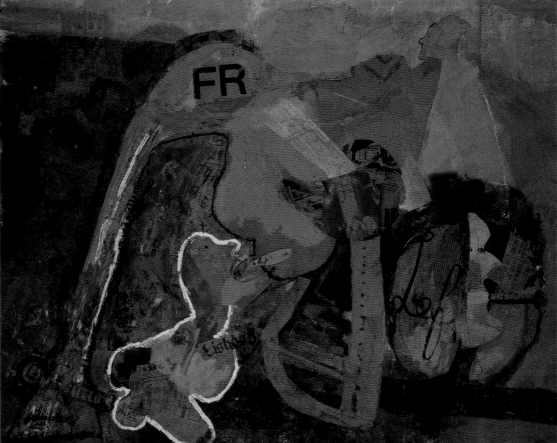

WHEN WE HAD A HOUSE IN THE
COUNTRY 1961 [7]
Oil and collage on canvas
49.5 × 244.5 (19 ½ × 95 ¼)
Collection of the artist

completes with ironic mock-nostalgia: 'we used to give marvellous parties and then go out and shoot the negroes'.

There is much Surrealism in these early pictures, both in the formal qualities they share with work by artists such as Max Ernst and Joan Miró made in the 1920s, and in the links between gesture (frantic drawing, seemingly mindless cutting up) and the unconscious revelation of meaning. Surrealism came late to Portugal, and Rego was interested in it from childhood, fascinated by the idea of spontaneous imagery enshrined in the Surrealists' initial quest for what André Breton in the *First Manifesto of Surrealism*, 1924, called 'pure psychic automatism, by which one intends to express verbally, in writing or by any other means the real functioning of the mind'. The Surrealist picture plane was a site for the collision of interior and exterior, of reality and the imagination, and its influence may be clearly seen in Rego's work at this time. Crowded with incident, her pictures mix the real with the invented, the willed with the unconscious, as she worked, as she has put it, to surprise herself with her own forms.

The Exile 1963 (fig.8), for example, is a potent mixture of the conscious and the unconscious. It shows a man, seen in profile in the centre of the picture, wearing a pin-stripe suit and pining for his homeland, from whose current politics he has deliberately exiled himself. He dreams of better times (his wedding is represented by the figure of the bride to his right) and he lets his mind wander, as has the artist, into unrelated, meandering stories. A detailed narrative is painted into the left-hand side of the picture, reminiscent of the complex tales told at great length for children, and involving a witch cooking pancakes that are immediately stolen by a naughty boy and girl. The witch merges with the more erotic, nostalgic fantasies of the exile concerning his bride, and the result is a classic confusion of experience and metaphor.

The work Rego made in the 1960s brought her to public notice, and in 1965–6 she had her first solo exhibition at the Galeria de Arte Moderna, Sociedade Nacional de Belas Artes in Lisbon. The show was successful, and also controversial: Rego was seen as a political artist, and as a painter of violent methods and imagery. It was a difficult time for her. Although she enjoyed the attention given to her work, and agreed to represent Portugal in the São Paulo Biennial in 1969, this period of professional success coincided with personal trauma. Rego's father died in 1966, and in the same year Willing was diagnosed with multiple sclerosis. He stopped painting, taking on the running of the family business in the absence of Rego's father. He managed the factory until 1974 when, ruined by the Portuguese Revolution (with which they were nevertheless in sympathy), Rego and Willing moved back to London and to a life supported solely by their painting.

A marked change in Rego's work towards the end of the 1960s was her adoption of acrylic instead of oil paint. The bright colours of acrylic paint matched the spirit of the times, while the increased spontaneity it

THE EXILE 1963 [8] top
Oil and collage on canvas
152 x 152 (59 7/8 x 59 7/8)
Collection of the artist

THE PUNISHMENT ROOM 1969 [9]
Mixed media on canvas
120 x 120 (47 1/4 x 47 1/4)
Private Collection, Portugal

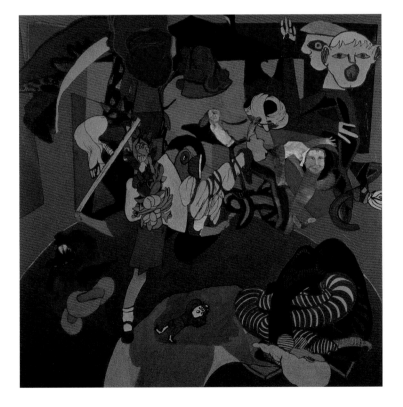

affords (acrylic dries much more quickly than oil, and requires less paraphernalia) appealed to Rego, and the change of medium radically altered the appearance of her painting. The colours are more vivid, the surfaces flatter and less tortured, with shapes sinking into the support rather than writhing around on top of it. Nevertheless, the violence embodied in the mutilation which remained an intrinsic part of the picture-making process is still there, and perhaps all the more shocking because of the increased legibility that the acrylic gives to the forms. The headless and limbless figures who inhabit 1969's *The Punishment Room* (fig.9), for example, share a peculiarly vivid anguish.

Rego worked in acrylic and with collage throughout the 1970s, finding new inspiration from Portuguese fairy tales, which she was awarded a Gulbenkian grant to study in 1975, and exhibiting her work to great acclaim in the Royal Academy's 1978 survey of contemporary Portuguese art. She became suspicious of her own method of working, however, telling her friend Helmut Wohl in a letter that she was unconvinced by both the gaps between the forms and the forms themselves. Finally, encouraged by fellow Portuguese artist João Penalva, who urged her to stop massacring her forms, and supported by the writer Rudolf Nassauer, who took her to look at Old Master paintings in Italy and Spain, she stopped making collage and began the 1980s with a radically new way of painting.

The best description of this work is that given by Victor Willing in 'The "Imagiconography" of Paula Rego', published in *Collóqio* II, April 1971, Lisbon. He analyses the artist's working methods and provides 'some clues towards an investigation of the contents' of some of her recent pictures. He writes:

Originally called Dogs of Barcelona, *the picture began when a short report appeared in* The Times *saying that the local authorities of Barcelona had decided to solve the problem of the growing number of stray dogs by feeding them with poisoned meat in the streets of the city. A number of dogs died in front of passers-by. The frieze of dogs running across the picture echoes in form the printed words sometimes used in the artist's previous pictures. Below the frieze raw flesh and the writhing forms of dogs are harassed by enormous flies. The white figure in the centre bottom of the picture derives from a Lazarus licked by dogs reproduced in a book of Catalan primitive artists (then a recent present from the artist's husband).*

It happened that when the picture had reached an impasse, the security of the family was threatened by a girl. The artist introduced this girl in the dark, heavy, reclining form pressing into the top of the picture. An angry hour's work, this figure representing sloth, indifference and immediate self-interest made the theme of the painting clearer in the mind of the artist and forced the picture to a conclusion.

The picture is one of the best-resolved examples of Rego's early technique. Collage and acrylic on canvas, it consists of a plethora of semi-abstract forms which have been drawn and painted, cut out and cut up, then re-assembled and painted around and over until the desired composition is reached. Rego has described her technique of the time as orgiastic, visceral and violent, remembering that she took intense pleasure both in creating the forms and doing violence to them.

As with all the pictures of this period, the forms which inhabit the finished work began life as characters in a particular story that the artist wished the picture to tell. As they came into being, however, they evolved, and in turn changed the meaning of the picture. Willing makes much of these changes, acknowledging a latent meaning underneath the narrative which gives it its title. He describes Rego's practice in terms of a searching out of meaning:

The story paraphrases the true content, which is unknown to the artist initially. As the layers of collage material are glued down and those parts which feel wrong obliterated or modified, this content is gradually revealed until it reaches a stage when the artist feels that the picture has solved, or rather purged, an emotional problem.

Crucially, however, the search for meaning is not halted for the artist once the picture is finished, nor for the viewer once its origins in both the newspaper story and personal experience have been revealed. The forms, not abstract but nevertheless difficult to read, demand constant re-interpretation as they shift in both formal and conceptual relation to one another. The shapes could be flies and dogs, as suggested by Willing, and at least one of them could be another figure. The torment of the central figure, its reference to the dead and resurrected Lazarus of the Bible offering only one of a number of possible ways to read it, comes in and out of focus depending on how we read the shapes around it and the date – 25 November 1963 – which emerges from its mouth in some sort of speech bubble. The date seems to be important, given that it is not the date of the picture, but possibly the date of the newspaper report, or perhaps an important date in the political history of Portugal. The work therefore seems to be both a political and a history painting. The frieze of forms, which also shift and resolve themselves variously into dogs, crouching figures and word fragments, gives the painting a solemnity which suggests some kind of a statement on the part of the artist.

The process of deciphering the picture, re-playing as it does the process of putting it together in the first place, is an important part of its impact. Separating figure from ground and figure from figure, unravelling the various elements at work within the shallow space of the picture, offers an insight into the complex system of logic which structures the work, the artist's handling of form and the complexity of her approach to narrative.

STRAY DOGS (THE DOGS OF BARCELONA)
1965 [10]
Oil and collage on paper
160 x 185 (63 x 72 7/8)
Private Collection, Portugal

RED MONKEY OFFERS BEAR
A POISONED DOVE 1981 [11]
Acrylic on paper
69 x 101 (27 1/8 x 39 3/4)
Caroline Willing

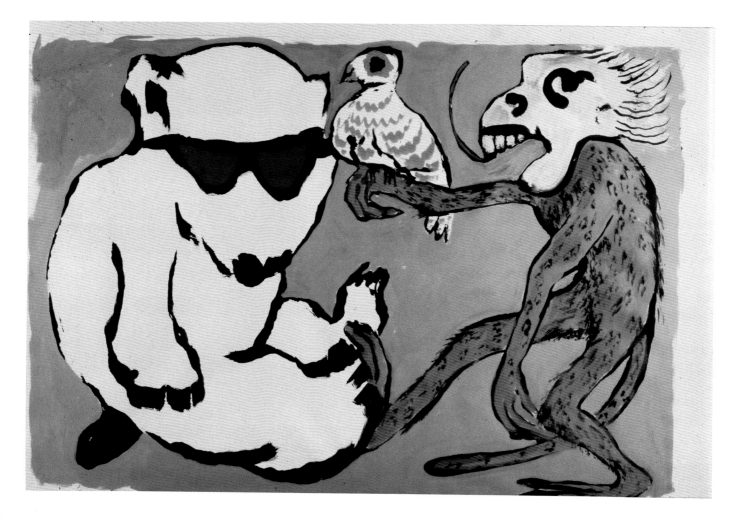

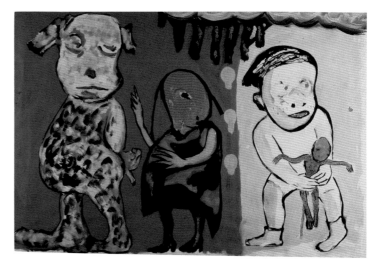

BEAR, BEAR'S WIFE AND SON PLAY
WITH RED MONKEY 1981 [12]
Acrylic on paper
69 x 105 (27 1/8 x 41 3/8)
Private Collection, Portugal

ANIMAL PAINTINGS

In 1981, the red monkey burst into Rego's painting. Inspired by Willing's recounted childhood memories of playing with a toy theatre whose cast of actors was limited to a monkey, a bear and a one-eared dog, the red monkey brought with him a new energy and a fresh technique. In a series of small paintings featuring him, Rego developed a way of working which retained some of the spontaneity and visual anarchy of her best collages, while leaving her characters physically intact. That the pictures are swiftly drawn in acrylic on paper, the forms made up of strong lines and large areas of saturated colour placed on flat, neutral backgrounds, keeps them visually close to collage. The paintings are essentially narrative, their stories carried by the strength of the characterisation and, very occasionally, by the inclusion of significant props.

The red monkey pictures tell one story, a universal tale of love and betrayal, security and insecurity within family relationships. The protagonists are humans thinly disguised as animals, Rego using animals not in accordance with any obvious symbolic system, but rather as children do in imaginative play, when it is perfectly natural for a cuddly animal to behave like a person rather than a bear. Rego's characters remain constant within the series from one picture to the next, although their physical appearance often changes. Like the heroes of animated cartoons, whom we are trained from an early age to recognise even as they suffer the outrages of cartoon life – being shrunk, blown-up, flattened, redrawn and updated – Rego's monkey and his friends retain certain characteristics through which we maintain our emotional connection. The key may be in their colour (the monkey is always red), their expression (the bear is always shifty) or their demeanour (the red monkey's wife is always the catalyst for action).

The paintings in the series all feature three participants. In *Red Monkey Offers Bear a Poisoned Dove* (fig.11), the cocky monkey, his mask-like, skull-like face contorted into a confident grin, holds out a dove to a bemused, sunglasses-wearing bear. The dove is the monkey's wife, and he is giving her to the bear to play with. His magnanimous sexual self-confidence does not last long, however: we next see him, in *Red Monkey Beats his Wife* (fig.13), punishing his unfortunate spouse while the bear character (somewhat inexplicably temporarily transformed into a lion) impotently hangs his head. The wife stands, belligerent, with her illegitimate child, and all the action is focused in the monkey, his nostrils flaring and his teeth set as he raises his fist to his wife. She gets her revenge, however, in *Wife Cuts off Red Monkey's Tail* (fig.20, pp.28–9), her enormous scissors flashing as she takes on her husband's colour, her eyes glinting strangely green as she undoes him. His visceral reaction makes clear the importance to him of his presumably euphemistic tail, and the bear shuffles off, hugging himself protectively. In *Bear, Bear's Wife and Son Play with Red Monkey* (fig.12), the red monkey's emasculation is complete: he has dwindled into a toy, a martyred, crucified, lifeless object, played with rather half-heartedly by a boy whose round eyes identify him as both the son of the bear in the previous picture and the baby in *Red Monkey Beats his Wife*. His parents look back, not entirely without guilt.

The savagery of Rego's imagination saves the saga of the red monkey from the whimsy that inevitably threatens to engulf any re-imagining of human emotion through animal characters. A similar atmosphere of domestic tyranny and casual cruelty pervades the scenarios she explores in the paintings that follow the red monkey series, in which we meet a cabbage, uselessly weeping while an insouciant rabbit wields an

RED MONKEY BEATS HIS WIFE
1981 [13]
Acrylic on paper
65 x 105 (25 5/8 x 41 3/8)
Collection of the artist

PREGNANT RABBIT TELLING HER
PARENTS 1982 [14]
Acrylic on paper
105 x 137 (41 3/8 x 54)
Private Collection

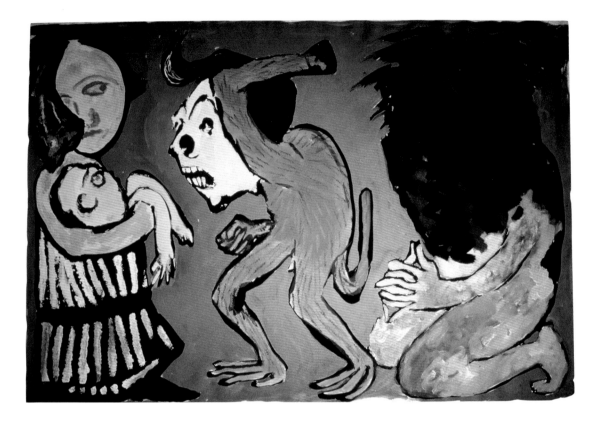

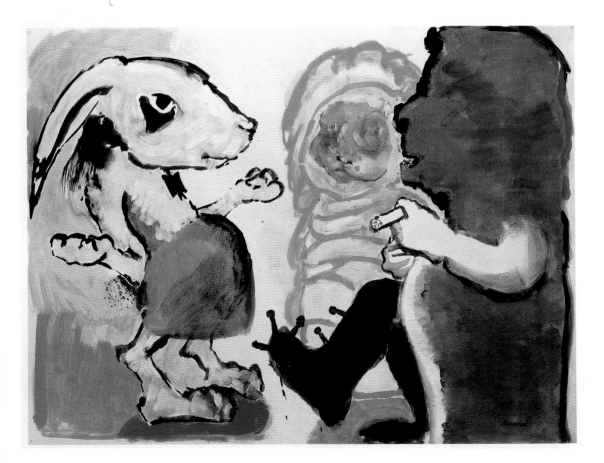

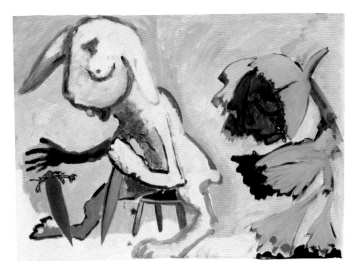

RABBIT AND WEEPING CABBAGE
1982 [15]
Acrylic on paper
103 x 141 (40 ½ x 55 ½)
Private Collection

enormous knife and an equally enormous carrot (fig.15); a ferocious monkey whose idea of fun is hypnotising the unfortunate chickens who, flat on their backs, litter the ground around him; and, perhaps the most true-to-life of them all, a pregnant school-girl rabbit, who shrugs nonchalantly at her immense, hob-nail booted, cigarette-smoking father while her panicking mother fades into the background (fig.14).

The immediacy of the mapping of human onto animal in these pictures seems inextricably linked to the mechanism of drawing. Unplanned and unmediated through preparatory work, the characters arrive on the sheet of paper directly from Rego's mind and memory. They are often based on people she knows – the weeping cabbage is famously a representation of her mother ironing, and it is hard not to see something of the artist herself in the recklessly pregnant rabbit – but her mind's eye is very much subject to the control of her hand. The characters in these pictures are drawn into life, taking control of their situations the minute they hit the paper. Not quite caricatures, they nevertheless make their point through limited means, inhabiting the paper itself rather than a fully-imagined world of their own. Theirs is the flat space of the picture plane or perhaps, given their origins in the toy theatre of Willing's memory, the proscenium arch.

In 1983 Rego was invited by Moira Kelly to participate in an exhibition of English art in New York called *Eight for the Eighties*. There was money for new work, but only two months in which to make it. Casting about for a story as full of visual potential as the red monkey's, Rego resorted to her own childhood memories, specifically those of trips to the opera with her father, and made twelve enormous paintings. Opera gave her ready-made stories with strong plots and a wealth of incidental detail, which she piled into the paintings according to a loose though more or less explicit structural grid. Working with the paper flat on the floor (only later laying it onto a stretched canvas), Rego plotted the pictures in horizontal bands running from left to right and from top to bottom, following the pictorial conventions of strip cartoons or, perhaps more appropriately, film storyboards. Her opera paintings are articulated by the same thick, energetically drawn line that characterised the red monkey series, only here it takes over completely. The palette of colour is reduced to near monochrome; red, white and black playing over the cream of the ground. Entire worlds, sufficient unto themselves, the pictures establish their own conventions, their scale shifting according to narrative importance rather than illusionistic spatial organisation, major incidents supported by a plethora of incidental visual detail.

The fact that the operas came to Rego via her memories of attending them with her father may account for the particularity of her presentation of them. She draws the stories in narrative and emotional short-hand, focusing on the main theme in order to attract the viewer's attention in much the same way as one might seek to engage a child in the most appealing aspect of the story. The pictures highlight the big, possibly the most operatic issues – again family relationships, though now fathers and daughters as often as loving couples. The fathers and daughters are the strongest characters, while the lovers are often somewhat weak, like the gormless monkey at the centre of *Aida* (fig.16) who eventually metamorphosises into the benign but useless crocodile who visits the daughter in the bottom right-hand corner. As the daughters square up to their fathers, Aida having to deal with a particularly over-bearing rabbit, our attention may be diverted by the supporting detail – an animated ball and chain, a bird-headed umbrella which looks a little too life-like.

The pictorial and narrative conventions developed

AIDA 1983 [16]
Acrylic on paper
240 x 203 (94 1/4 x 79 7/8)
Collection of the artist

THE PROLES' WALL 1984 (detail) [17]
Acrylic on paper
244 x 1220 (96 x 480)
Gulbenkian Foundation, Lisbon

in the opera series reach their climax in *The Proles' Wall* of 1984 (fig.17), commissioned by Camden Arts Centre as part of *1984*, an exhibition marking the moment when the present caught up with George Orwell's vision of the future. The enormous, mural-like picture is the result of Rego realising that the 'proles' – Orwell's uneducated underclass – would have had to draw rather than write in order to express themselves. Re-imagining Orwell's novel as a wall of graffiti drawn by the proles, she reduces his story to a series of principal incidents and, in a familiar strategy, an outpouring of supporting detail. It is possible to trace Orwell's story in the painting through its central characters (Winston Smith, the protagonist, is shown as a teddy bear, his tormentor a real bear), but the index of *The Proles' Wall*'s relationship to *1984* is not primarily that of illustration. As with the red monkey and the operas, the book provides a starting point, a cast of characters and a certain narrative impulse sustained by the shifting relationships in which the characters become enmeshed. The memorable incidents in *The Proles' Wall* are memorable in and for themselves, rather than in their ability to signal Orwell's novel. The bear manacled in misery while a girl dances with an animated microphone, the painting camel, the bear who tumbles in to torment a trembling victim, the girl submitting furiously to an injection being administered ignominiously by a grinning wolf, all exist within the dynamics of the picture and the imagination of the artist rather than the book or the writer.

Although they are outnumbered by animals, girls exist in all of Rego's cycles of paintings from the early 1980s. Whether shrugging, swooning, shaking unresponsive monkeys or even preparing to hang boys whose only crime seems to be to want to dance with them, the girls generate much of the pictures' energy.

In many ways, they are the precursors of the Vivian Girls, with whom Rego took up after an encounter at an exhibition of Outsider Art, held at the Whitechapel Art Gallery in 1979, with Henry Darger's illustrated novel, begun *c*.1905, *The Story of the Vivian Girls in What is Called the Unreal or the Glandelion War Storm or the Gaudico-Abbenian Wars as Caused by the Child Slave Rebellion*.

Darger was a self-taught, amateur artist who worked by day as a janitor in a Chicago hospital. His style is horrifically inventive, his book a compendium of violence perpetrated on and by the Vivian Girls, armies of pre-pubescent girls traced by Darger from illustrated children's books and magazines. Darger's images obey their own stylistic and narrative rules, operating outside every possible pictorial convention. Fascinated, Rego borrowed the girls, painting a sequence of anarchic, exuberant works that moved her away from the formal, near-monochromatic rigour of the operas and *The Proles' Wall*.

Rego's Vivian Girls paintings (1984, figs.18, 19) are plotted directly from her imagination as snapshots or tableaux-vivants rather than stories developing sequentially down and across the picture. Although the entire space of the picture plane is used, the forms stack up in the space with reference more to the traditional understanding of foreground and background than to the comic strip or story board. Colour is largely confined within line, working to define the elements of each painting. All the action seems to be happening simultaneously, with the girls in control. Although there are animals present, they are pets or props rather than protagonists and, paradoxically, the girls inhabit a far more fantastical world than the red monkey. His was the reality of the family, while theirs is an imaginative world of giant prawns and anthropomorphic, unimpressed palm trees.

THE VIVIAN GIRLS WITH WINDMILLS
1984 [18]
Acrylic on canvas
242 x 179 (95 1/4 x 70 1/2)
Private Collection

opposite: THE VIVIAN GIRLS IN
TUNISIA 1984 [19]
Acrylic on linen
200 x 180 (78 3/4 x 70 7/8)
Collection of the artist

In these three cycles of painting, which mark the first half of the 1980s in Rego's work, ready-made stories and characters predominate. Yet the artist does not set out to illustrate them. Rather, she seeks their essential meaning, the point at which they coincide with her own experience and interests and, like a filmmaker storyboarding a number of versions of a novel in order to determine which will work best as a film, adapts them to her purposes. The effect of her re-working is to render the stories open to a multiplicity of interpretations. The viewer is free to read the actual story of the opera into *Aida*, or to construct a new narrative from its cast of characters. The freedom of the viewer is crucial to Rego, and it is a freedom she paints into her pictures and claims first of all for herself. Her characters do not do what she originally had in mind for them, and she does not want them to. What she wants is to make them and their situations up as she goes along, so that the stories float freely, able to drift in and out of new connections with the present. If you ask Rego what a picture is about, she will always tell you, and will always tell you the truth. Yet the truth changes with time and mood, as the artist is more interested in how each work acts and reacts in contemporary situations than in what it may have meant the day she started or finished it. Truth and fiction, and the multiple truths of fiction, continue to drive and shape the work long after it is finished.

Paula Rego looks on her work as an open text, a repertoire of imagery and characters which, although created by her at specific times for specific reasons, nevertheless have a life of their own and remain open to new interpretations – often her own. A recent conversation about this particular picture and the series of which it is part covered some familiar ground, but also opened up a new way of looking at the narrative's central motif:

PAULA REGO I was drawing monkeys to make a collage, but as I was about to cut them up, João Penalva said not to, that they looked too nice. So I thought OK, I'll leave them, and think about what to do with them as they are. Then I read Jorge Luis Borges's *Book of Imaginary Beings* (1969) and started trying to make pictures of the creatures he described. Finally, Vic told me about the toy theatre he had as a child, about the monkey, the bear and the dog with one ear, which were his toys when he was very young. I drew the three toys on a large piece of paper. The dog quickly disappeared, but the monkey and the bear I recognised as characters that I knew. And then I brought the woman in as well, to create a drama between the three of them.

FIONA BRADLEY Were you deliberately trying to work in a different style from your previous way of working, as well as with different subject matter?

PR Yes. For the first time in a long while, I was aware that I was drawing something that was not going to be cut up. So I drew with more attention to what was going on – with a purpose really, and one other than to create raw material. The whole collage thing had become rather academic, and all about process rather than ideas. I had become stuck. This animal drawing was an attempt to get back to something direct. But not like illustrating an idea, because for me the idea always comes afterwards, once I've already got the character.

FB Was this the first time in your work that animal characters started to direct the action of a story?

PR I had drawn men as animals before, in a small sketchbook (1953), and for a big picture illustrating de Sade's giant, Minski. One of the creatures in there, a beetle man stranded on his back, waving his legs in the air, already had the beginnings of this in him. But he was from a story I didn't know anything about, whereas this new work was with a story I was absolutely involved in.

FB When you draw anthropomorphic animals like these, do they start off as animals and become people, or the other way round?

PR Neither. They start off as what they are: peopley animals; animaly people. These just came out like this, and then I began to think they looked like people I knew.

FB Do you generally see people as animals?

PR No.

FB Did you do much preparation for the pictures in the red monkey series?

PR None at all. They were done directly onto the paper – straight off, no studies, no nothing. There isn't one pencil mark on them. They were done direct, with a large brush.

FB And did you always know they were going to make a story?

overleaf: WIFE CUTS OFF RED MONKEY'S TAIL 1981 [20]
Acrylic on paper
68 x 101 (26 3/4 x 39 3/4)
Waldemar Januszczak

PR Not at first. Not until the one where she comes home unexpectedly with her lover's child, and the monkey gets so furious that he hits her. It all came from that one. Then she cuts off his tail, and turns into a dove. In revenge, he gives the dove – it's poisoned – to the lover and kills him. It all happened on the paper – even the lover covering his face with his hair in *Red Monkey Beats his Wife*. He looks like a penitent saint – Magdalene. But it happened because I made a mistake and needed to cover it up with something that would work for the picture. I thought it was important to leave everything exactly as it was so that it would look real. It always seemed completely real to me.

FB Did the fact that the characters were animals help you with the story?

PR Absolutely. It was the truth as I saw it at the time. Doing it with animals made it possible. With people it would have looked totally absurd – I couldn't have done it. The monkey is the strongest character all the way through, even in this picture. Look at his wife, she's barely there, she exists only in stripes. It's the scissors that are important – she's only a shadow holding them up. She's not really a real person. But he is, and he's suffering like mad. The bear is no one – he's a toy really, running away. He's important, because without him there'd be no drama, but he's important only as the instigator, the trouble-maker.

FB Is it a castration image?

PR I should think so. Probably. I think what it is actually is an image of separation, of incomplete separation. Look at that green limb she has attached to her – a sort of third leg. It's not the monkey's tail, though people have thought that it was. She's trying to cut him away from her, but she can't completely – he leaves a little part of himself attached to her, just as he vomits some more of himself onto the ground. He is too real to her – she cannot get him away from her. The bear is just something she uses to get the monkey away from her – another pair of scissors if you like. He's an instrument of her liberation from the monkey person, but the liberation is incomplete.

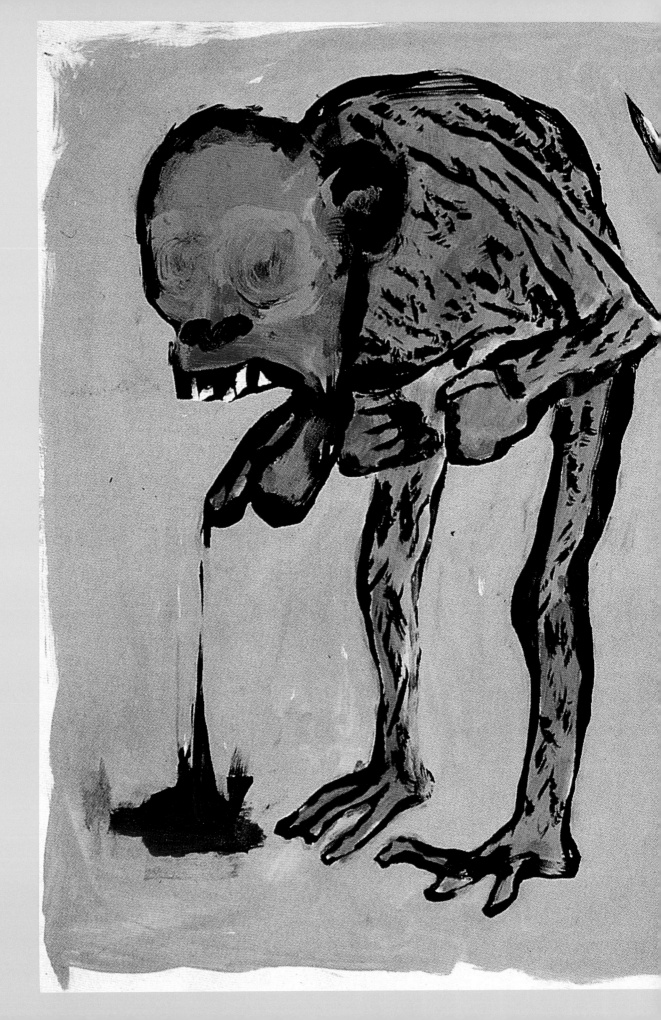

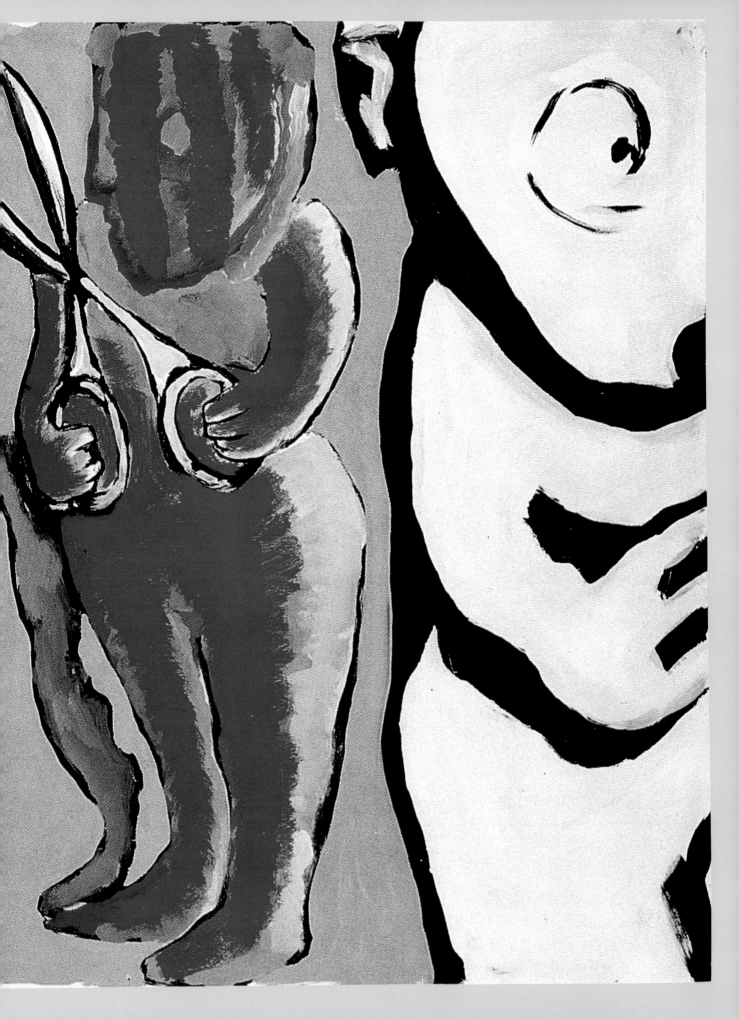

UNTITLED (GIRL AND DOG) 1986 [21]
Acrylic on paper
112 x 76 (44 1/8 x 29 7/8)
Private Collection

UNTITLED (GIRL AND DOG) 1986 [22]
Acrylic on paper
112 x 76 (44 1/8 x 29 7/8)
Private Collection

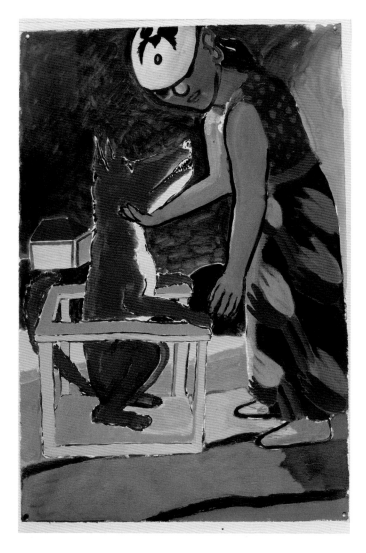

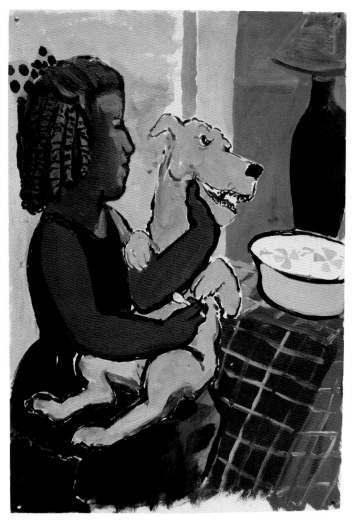

3

FAMILY PICTURES

The red monkey and his entourage brought Rego success in London, and in 1985 she was again invited to show in the São Paulo Biennial, this time as Britain's official representative. In 1998, she was offered a retrospective exhibition by José Sommer Ribeiro at the Gulbenkian Foundation in Lisbon. Alistair Warman of the Serpentine Gallery selected work from this exhibition for a smaller solo show, and this confirmed her reputation in Britain. Again, professional success was undermined by personal loss: the exhibition's opening in London coincided almost exactly with the death from multiple sclerosis of Victor Willing and much of the new work in it was completed in the shadow of his deteriorating health. The pictures are imbued with his presence. Willing was Rego's intellectual and conceptual collaborator, pushing her to find a way through any difficulties presented by a painting, and feeding her with ideas and inspiration.

Two cycles of work formed the main focus of the Serpentine exhibition: a series of small and medium-sized pictures of girls and dogs, and several vast family narratives. The girls and dogs series (1986–7) had been shown before, at the Edward Totah Gallery, where they attracted much attention, and were instrumental in Rego's move from Edward Totah to Marlborough Fine Art, the gallery that has represented her ever since. Although clearly a new body of work, the girls and dogs pictures continue several of the formal and narrative characteristics of Rego's earlier output. The series begins with eight small paintings in acrylic on paper, all featuring a girl caring for a dog. The forms within the pictures are anchored to the bottom of the paper as they were in the red monkey paintings, the artist rejecting this time the vertical freedom of the operas or even the Vivian Girls. These new paintings have much more of a sense

of location than the red monkey series, and their settings have less of an air of theatrical improvisation. This is partly due to the few, well-chosen props, more reminiscent perhaps of the visually eloquent trappings of the Vivian Girls. Although clearly located, however, neither characters nor props cast shadows – the forms are layered onto the flatness of the paper rather than settled in pictorial space.

The eight paintings tell a simple story based around a relationship: that of a girl with her dog. As we might expect, the appearance of both girl and dog changes from one picture to the next, the changes marking shifts in the relationship and corresponding alterations in the girl's sense of her identity both in and out of the couple she forms with her dog. The pictures are primarily about the girl, with the dog as pet and prop, capable of taking on a variety of roles from baby to lover. The dog, though an actor in the story in his own right, functions mainly as a partner in sympathy and in conflict with whom the girl may reach an understanding of who she has been, is and may yet possibly be.

One of the earliest in the series is a picture of encounter and appeal, the girl stooping to greet a small, foxy-looking dog (fig.21). Her opening gesture, her hand cupping the dog's jaw, is repeated in several of the following images, notably the one in which she coaxes a yellow dog, a strong and reluctant infant, to accept food on a spoon (fig.22). The meaning of the gesture changes as the dog becomes less active, wedged between her knees or reclining, docile, on her lap. Throughout the series, the primary point of contact between girl and dog is that between her hand and his jaw – a fact made obvious in an image of the dog being shaved (fig.25), in which the dog submits his extraordinarily long throat to the dubious caress of a cut-throat razor.

UNTITLED (GIRL AND DOG) 1986 [23]
Acrylic on paper
112 x 76 (44⅛ x 29⅞)
Private Collection

UNTITLED (GIRL AND DOG) 1986 [24]
Acrylic on paper
112 x 76 (44⅛ x 29⅞)
Private Collection

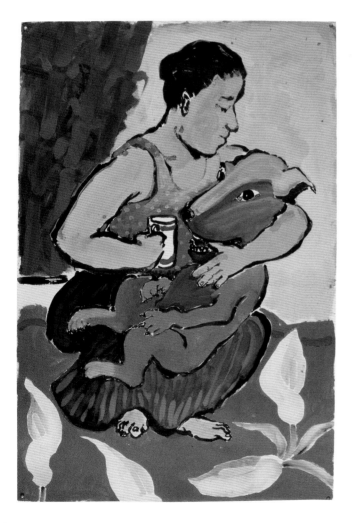 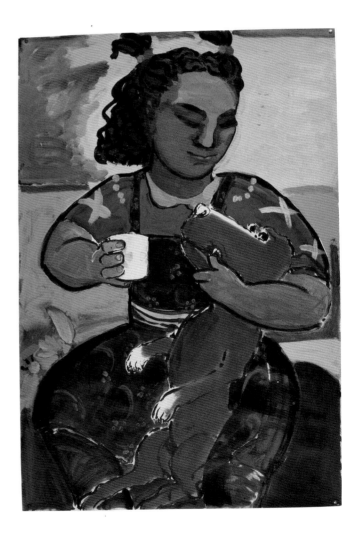

UNTITLED (GIRL AND DOG) 1986 [25]
Acrylic on paper
112 x 76 (44 1/8 x 29 7/8)
Private Collection

GIRL LIFTING UP HER SKIRTS TO
A DOG 1986 [26]
Acrylic on paper
80 x 60 (31 1/2 x 23 5/8)
Private Collection

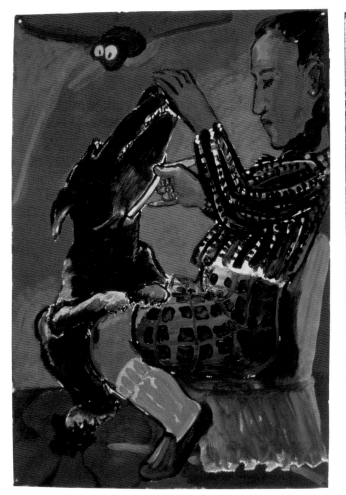

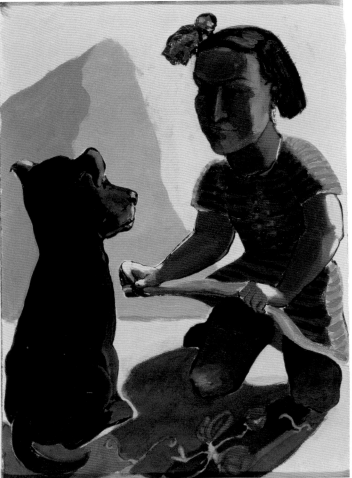

LOOKING BACK 1987 [27]
Acrylic on paper laid on canvas
150 x 150 (59 x 59)
Saatchi Collection, London

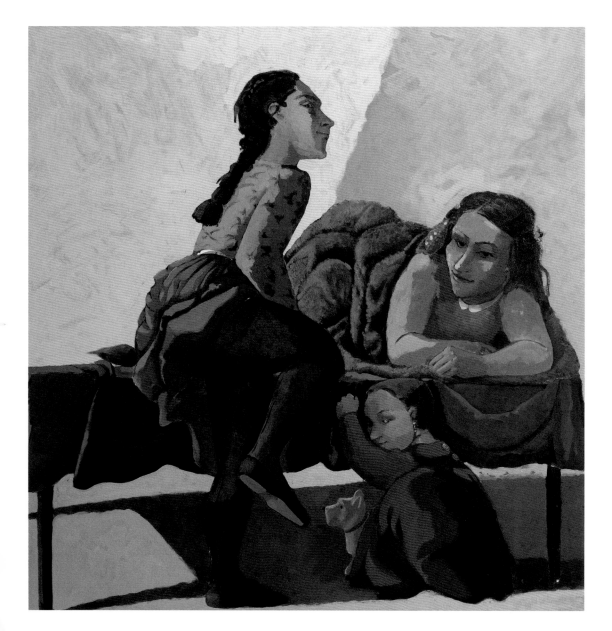

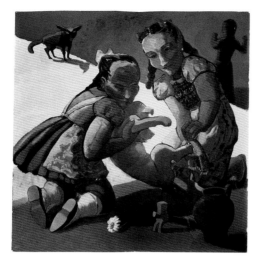

TWO GIRLS AND A DOG 1987 [28]
Acrylic on paper laid on canvas
150 x 150 (59 x 59)
Private Collection

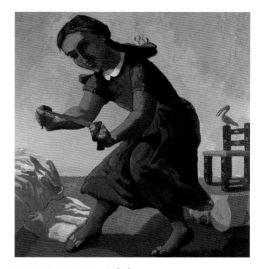

THE LITTLE MURDERESS 1987 [29]
Acrylic on paper laid on canvas
150 x 150 (59 x 59)
Private Collection

If there is some menace, or latent aggression, in this picture, it is more fully realised in the last painting in the series, *Girl Lifting up her Skirts to a Dog* (fig.26). Her face set into a mask of uncompromising challenge, the girl confronts a completely bemused-looking dog. Collecting and distilling both the sexual and the violent undertones of the preceding scenarios of feeding, caressing, grooming and teasing, the painting speaks of provocation and frustration, of being desperate for acknowledgement.

The complex ambiguity of a relationship in which love and anger, desire and frustration coexist, remains the subject of Rego's subsequent girl and dog paintings. These next works are bigger than the first, still painted in acrylic on paper, but with the paper mounted on canvas to give the paintings a more finished, less improvisatory appearance. Like *Girl Lifting her Skirts to a Dog*, the scenes are mostly set outside, in strong light, which, for the first time in Rego's painting practice, casts shadows. The forms are tonally modelled as well as clearly drawn, and they begin to inhabit space more firmly, although they still seem scaled according to the artist's interest in them and their importance to the story rather than to any externally imposed law of pictorial composition.

One of the most complex of these pictures is *Two Girls and a Dog* (fig.28). In it, the girls play with the dog like a doll, dressing and undressing it in human clothes. In the background, a shadowy girl confronts a dog at once wilder – it looks more like a wolf or a fox – and less realistically painted. Its eyes are the same colour as the sky behind it, a device which renders it as insubstantial as a phantom or apparition. In the foreground, a flower, hammer and pottery jug seem ripe for symbolic interpretation, the flower a symbol of fragility, the hammer ominously close to the breakable jug. Potential beginnings and endings proliferate

in both the narrative and the compositional devices used to present the story, whose middle section we see. To complicate the moment of seemingly innocent play, Rego borrows from the traditional Christian iconography of the deposition – the moment when Christ's body is taken down from the cross. As the children lay down the body of the dog, the girl and wilder dog in the background seem to take up symmetrical, flanking positions on the suddenly menacing slope of the hill. The hammer changes from the symbolic to the functional, a practical instrument of torture. The picture is far from literal, but it stalks the crucifixion in its exploration of the darker implications of love, trust and dependence, its almost casual equation of cruelty and play.

In *The Little Murderess* (fig.29), the dog has fled the canvas, pursued by a girl whose intentions seem far from ambiguous. She may have mistletoe in her hair, but she clearly desires more to strangle the dog than to kiss it. In *Looking Back* (fig.27), the last of the series, it appears as though she may have succeeded. She is joined by two other girls, one of whom seems to be returning to the space of the picture after having dispatched some presumably unpleasant business. All the girls look sly, clustering together around a suspiciously furry-looking blanket, a toy dog cowering pathetically under the bed.

The implied death of the dog in *Looking Back* marks the end of the girls and dogs paintings, and the end, too, of one particular way of working with animals. Having used them to capture, distil and express the essence of humanity, Rego moves on. Although animals continue to feature in her work, as familiars and as commentators on the action, the narrative charge of each picture is carried by the human relationships within it. The artist remains faithful to her girls, however, who grow up to

THE MAIDS 1987 [30]
Acrylic on paper laid on canvas
213.4 x 243.9 (84 x 96)
Saatchi Collection, London

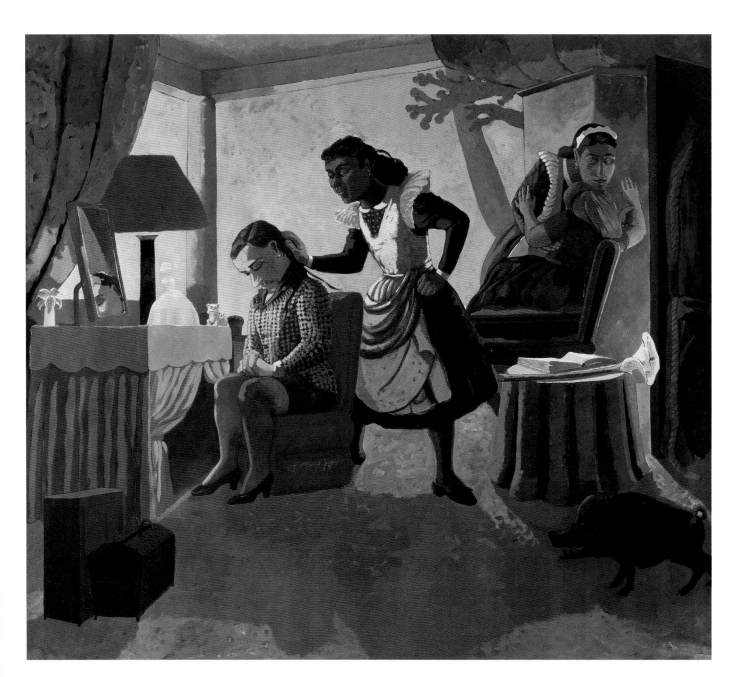

STUDY FOR THE MAIDS 1986 [31]
Pen and wash on paper
29.6 x 42 (11 ½ x 16 ½)
Collection of the artist

STUDY FOR THE MAIDS 1986 [32]
Pen and wash on paper
29.6 x 42 (11 ½ x 16 ½)
Collection of the artist

encounter more and more complex pictorial situations, still as daughters and lovers, but also as wives and mothers and even, eventually, grandmothers.

Around the time of *Looking Back*, Rego returned to drawing from life to help her develop the complex narrative and emotional situations of her girls in their new role as the principal protagonists of more involved family dramas. An idea for a picture (whether directly from her imagination or derived from a ready-made story) in her head, Rego began to ask models (rarely professionals) to work with her in mapping out potential ways of expressing it. From individual poses to entire scenarios, she thought through her ideas in visual form, making a sheaf of drawings for each picture. Once confident that a story was going to make a picture, she began to paint, often asking the model to pose again, as the drawings were more often than not put to one side in favour of improvising around the original idea directly onto the canvas, with the model and the painted characters as likely as the artist to dictate the visual course of the action.

This procedure has become a constant feature of Rego's mature work. She is close to the models she uses regularly, her relationship with them an intrinsic part of her picture-making process, and one that she sees as essentially collaborative. She lets her model in on the secret of the story she wishes to paint, and together they choose clothes and props and play with a range of possible approaches. The model with whom Rego has had the closest relationship is the woman to whom she first turned when beginning again to draw from life. Lila Nunes, a young Portuguese woman, came to help the family during Willing's last years, just as Rego was preparing for her Serpentine exhibition. Strong-featured and dark-haired, Lila is the living incarnation of one of Rego's girls, and the model on which most of them are drawn. This figure

is often mistaken for Rego herself, as she turns up in the guise of the various personae who inhabit the artist's imagination. However, Rego is uninterested in the narcissism of the self-portrait, and her girls are never herself. It is other people who interest her; people she may initially create, but who go on to assert themselves pictorially almost in spite of the role she initially intended them to play.

After *Looking Back*, Rego made *The Maids* 1987 (fig.30), a huge painting whose only link with her earlier body of work seems to lie in the ambiguity of the paired couples, most tellingly expressed in the hand – protective or threatening? – laid by a maid on the back of her mistress's neck at the centre of the picture. This is a gesture straight out of the earliest girls and dogs paintings. Yet now the action is all between humans, and is set inside, in a recognisably Portuguese room. The story at the heart of the painting came to Rego ready-made in the form of Jean Genet's play *The Maids* (1947), itself based on the real-life case of the Papin sisters, Christine and Léa, who worked as maids for a rich Parisian family. One day, for no apparent reason other than that of a power cut which inconvenienced and possibly frightened the sisters, they brutally murdered the mother and daughter of the family while the man of the house was out at work. Their case was taken up by the French psychoanalyst Jacques Lacan, who saw in the sisters an example of a 'double delirium', sometimes manifested in close family relationships, a kind of paranoia in which reality outside the relationship is perceived to be of much less consequence than anything within. Lacan's analysis concentrated on the symbolic nature of the girls' crime and their fixation on the relationship of the mother and daughter with reference to their own. He noted that the girls acted out traditional metaphors of hatred, literally tearing

THE CADET AND HIS SISTER 1987 [33]
Acrylic on paper laid on canvas
213.4 x 152.4 (84 x 60)
Private Collection

their victim's eyes out, and that they became extremely physically involved in their crime, indulging in a strange ritual of quasi-sexual jealousy towards their employers, mutilating their corpses and spreading the blood of one onto the body of the other.

In working with the story, Rego seems to have focused, like Lacan, on the unnatural closeness of the sisters, both to each other and to the mother and daughter they murder. Before arriving at the twin embraces of maid and employer which structure the finished picture, she tried out a number of alternative ways of approaching the story in life drawings, studies and sketches from her imagination. In one drawing, the maids innocently help their mistress to dress (fig.32). In another, the first maid is already in the ambiguous posture of the finished painting, while in the background her sister openly attacks the young girl, whom later on she could just about be perceived as cuddling (fig.31)

Ambiguity and menacing psychosis reverberate within the picture, much of it carried in the objects with which the room is claustrophobically furnished. Many of these objects do not appear in any of the preparatory drawings. They have arrived into the finished painting either from the artist's head, summoned to carry out a conceptual role (as with the dressing gown on the back of the door, hinting at the absent father and the triangular position he occupies within the couples with which we are presented), or from her studio, pressed into compositional service as the picture progresses. Rego often speaks of the dual role of objects in her pictures: that they are there to help along both the story and the painting itself. Typical of this in *The Maids* is the wild pig at the bottom of the picture. Unsettling and de-stabilising in terms of meaning, its role is however primarily compositional, put there to balance the foreground.

This is a position Rego likes to fill, and she often does it with whatever comes to hand. The pig is in fact a version of a tiny pincushion she has in her studio, pressed into service at a vastly inflated scale.

Rego followed *The Maids* with a sequence of two-handed paintings exploring close family relationships. Sometimes both protagonists are present, as in *The Cadet and his Sister* (fig.33), and sometimes one is absent, if supremely so, as is the case in both *The Soldier's Daughter* (fig.91, p.118) and *The Policeman's Daughter* (fig.92, p.119). All the relationships seem somewhat dysfunctional, particularly those between the fathers and the daughters. The soldier's daughter is pining, her anguish at her father's absence played out in the figurines at her feet and taken out on the sacrificial goose between her legs, whose feathers she so painfully clutches. The policeman's daughter is angrier, her hand rammed into her father's boot as she cleans it. A drawing for the painting shows its genesis in a relationship that is a little more innocent – a younger girl, cradling the boot as she cleans it, a toy castle symbolising security at her feet. In the painting, the castle has become a mistrustful cat, and the pose of the girl, taken from a sexually-explicit Robert Mapplethorpe photograph, anything but innocent.

In *The Family* 1988 (fig.34), the absent father and husband returns to the picture plane, only to be manhandled by his daughter and his wife. As usual, the narrative clues are ambiguous, and the story could have several endings. Are the women helping the man or hurting him? Who is the little girl at the window? Do the clues perhaps lie in the Portuguese retablo featuring St Joan, and St George slaying the dragon? Or in the fable of the stork and the fox illustrated beneath? Is the man as doomed as the dragon, or will he in fact resurface like the fox, to eat the stork, once it has removed the bone lodged in his throat?

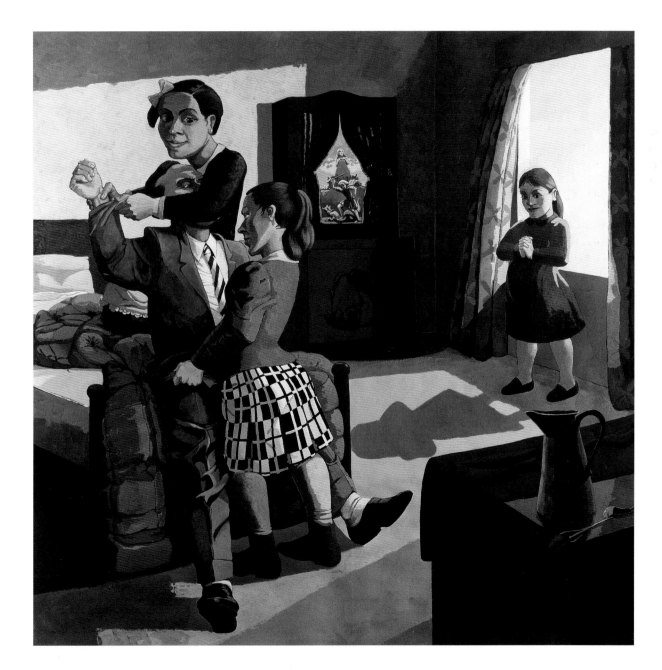

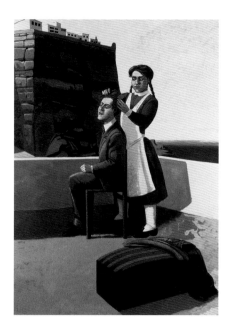

DEPARTURE 1988 [35]
Acrylic on paper laid on canvas
213.4 x 152.4 (84 x 60)
Collection of the artist

Two further pictures complete the cycle of family narratives displayed at the Serpentine. Both are out-door paintings, set, one by day and one by night, on the beach at Ericeira in Portugal where the artist used to live. *Departure* (fig.35) and *The Dance* (fig.36) were painted almost together, the former just before the Serpentine exhibition, and the latter immediately after it. In the first picture, a girl prepares a man to leave her. Although dressed as a maid, the stance she takes up in relation to the man is not one of subservience. Rather, she reminds us of one of Rego's girls with her dog; the man is her pet, her baby and her lover. An electric charge seems to pass through the comb which both connects them and is the symbol of their imminent separation. The girl's energy and attention are focused on the man, while he looks out of the picture, ready for the off. His going, we imagine, will leave her with nothing to do.

But not with nothing to be, for she shares kinship with the women of *The Dance*, all of whom have, in various ways, found roles for themselves and made their peace with who they are. A dance of life, the picture plays out the various ways in which a woman – the main character, painted larger-than-life at the left-hand edge of the picture – may structure her concep-tion of herself. As she looks out directly at the viewer, a number of ways of being a woman unfold around her. The three figures at the back form a happy triumvirate of child, mother and grandmother. The other two are in the early stages of life with a man – one courting, the other pregnant. Like them, the artist has said, the large figure was originally dancing with a man, but he dwin-dled throughout the preparatory drawings for the picture until he disappeared altogether. He is not needed, and his absence allows the large figure to make a link between the two couples in the foreground and the trio at the back, her direct gaze inviting the viewer to engage first with her and, through her, with the other figures who make up this multiple investigation of femininity.

THE DANCE 1988 [36]
Acrylic on paper laid on canvas
213.4 x 274.3 (84 x 108)
Tate

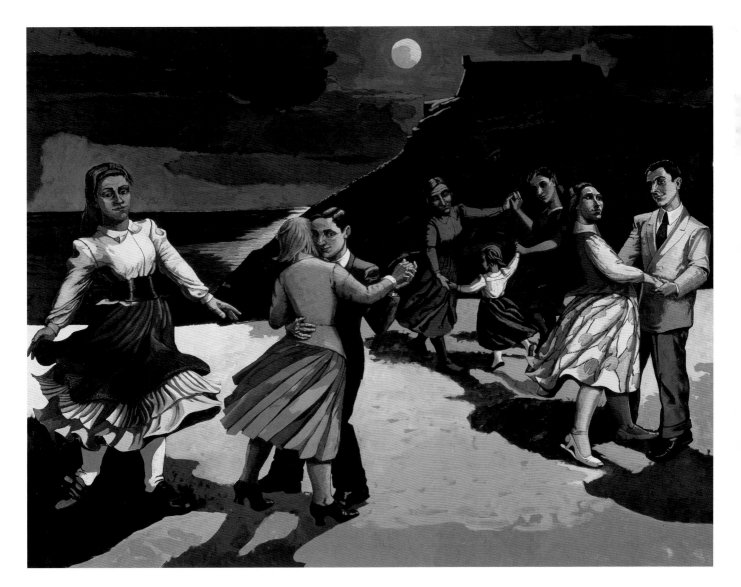

Drawing has always been fundamental to Paula Rego's working practice – as she said recently, 'I love doing it, and I love looking at it. Good drawings are more intensely alive than any other art – they are about being alive.'

Rego draws when she is, in her words, 'looking for a picture', whether narratively (searching for a story), or compositionally (seeking the best way to express a story through figures arranged across a canvas). She also draws when she is stuck; when she has finished an intense period of working and is casting around for something to do next.

Recently, the artist talked about the series of drawings made in preparation for the large picture *The Dance*, one of her most spectacular and best-known paintings. It is often viewed as something of a turning point or watershed in her work, although she herself would rather confer that status on *The Maids*, an extremely intense picture which the artist describes as having 'the tension of the red monkey and the narrative of something else rather dangerous and entirely to do with women'. *The Dance* was made over a long period of time, and a complete sequence of drawings exist, many of which the artist donated to Tate when the painting was acquired for the Gallery's collection.

These drawings were made when I was looking for the last picture for the Serpentine exhibition. It was to have been the picture that would tie everything together, hung over the top of everything else. But I didn't finish it in time, which was just as well really, as it ended up too big to fit in the gallery. Vic had said to do people dancing, so that was where the subject came from, but then it all got mixed up with his dying, and the drawings for the picture took me through a period of intense sickness and bereavement. Drawing can do that – get you through things. It's like in an old Portuguese joke, in which a man is up a ladder, painting a wall with a large brush. Another man comes along and wants the ladder, so he says to the first – 'Hold on tight to the brush, I'm just taking the ladder away . . .' This is what drawing is like – it grounds you, it connects you so intensely to the paper, through the pencil or the nib or whatever you use, that it is a lifeline when everything else is taken away. Things can go wrong, but if you just hang on tight to the paper and the pen, everything will be OK.

The drawings are all done from the imagination – no models. I think I had in mind Domenico Tiepolo and his beautiful pen-and-wash drawings of Pulchinello that both Vic and I liked so much. You always have another artist in mind when you work. You don't want to be yourself – you don't know who you are. Trying to be as good as someone else always works better. When you draw from your head, a great deal of mimicry goes on anyway – you have to become the figures you're drawing, putting yourself in the positions you're assigning to them.

overleaf: DRAWINGS FOR 'THE DANCE'
1988 [37]
Pen and wash on paper
Each 29.7 x 42.2 (11 3/4 x 16 5/8)
Tate

The first drawings were only of women, just women dancing. Several of them look as though they would have made paintings, except for this one where the girls look like a bunch of cabbages. But Vic thought it was boring without men, so he said to put some in. They came in to support the women, to mark various stages in their lives. In the finished picture, there's really only one man – first he's dancing with his wife, who's pregnant, and then we see him having an affair. The blonde girl he's with is the odd one out, she doesn't belong to the same family as all the other, dark-haired girls. The large figure in the foreground originally had a man – perhaps the same one again, as she might be looking back and forwards over various stages of her life as she stands there in the moonlight, and it might be her we see as a little girl, a pregnant woman in love, a mother, a woman betrayed, a grandmother. But her man disappeared. You can see him in some of the drawings, but when it came to the picture, I just couldn't fit him in.

This often happens to me. I had a finished drawing, with the composition all decided, which I squared up and transferred to the canvas. When I started to paint the picture, I got models in to pose, so that I could get the details right. With painting it's all much closer-up than it is when you're drawing from your head, and you can't imagine things as well, or perhaps you don't want to, so I use a model. I love the spontaneity of drawing, the fact that there's always so much life in it, but I don't want the paintings to be like that. Anyway, once I had the models to sketch, the painting started to change, and figures came and went. At one point the large rock was full of caves with hermits in, but they all vanished in the end. The figure in the foreground got larger and larger, lost her man and somehow began to sum up the whole picture.

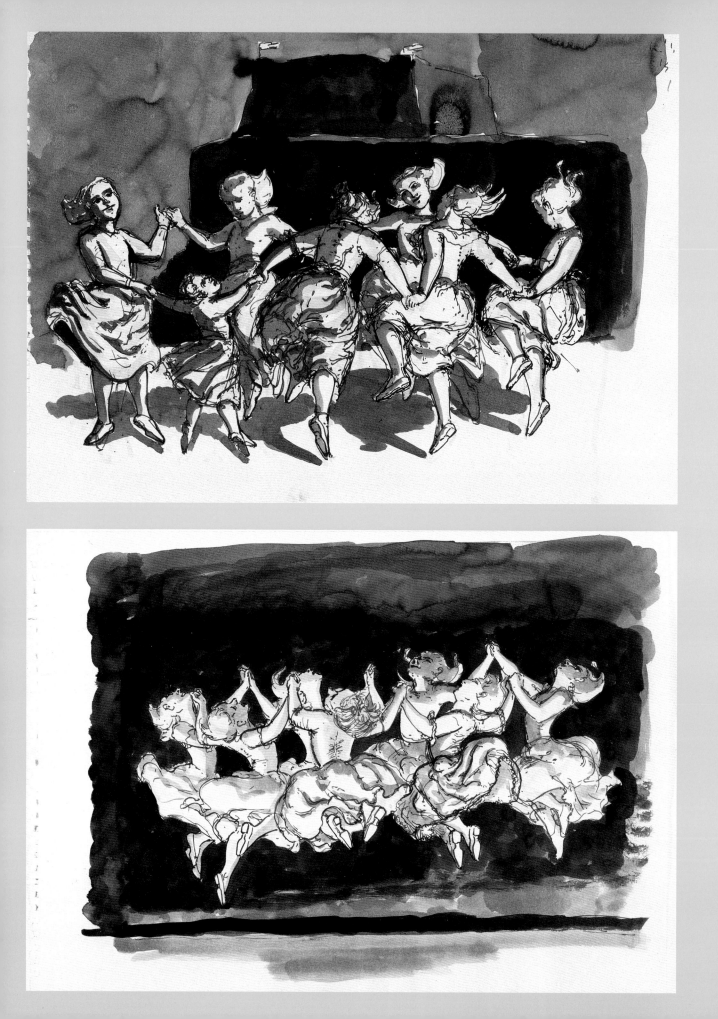

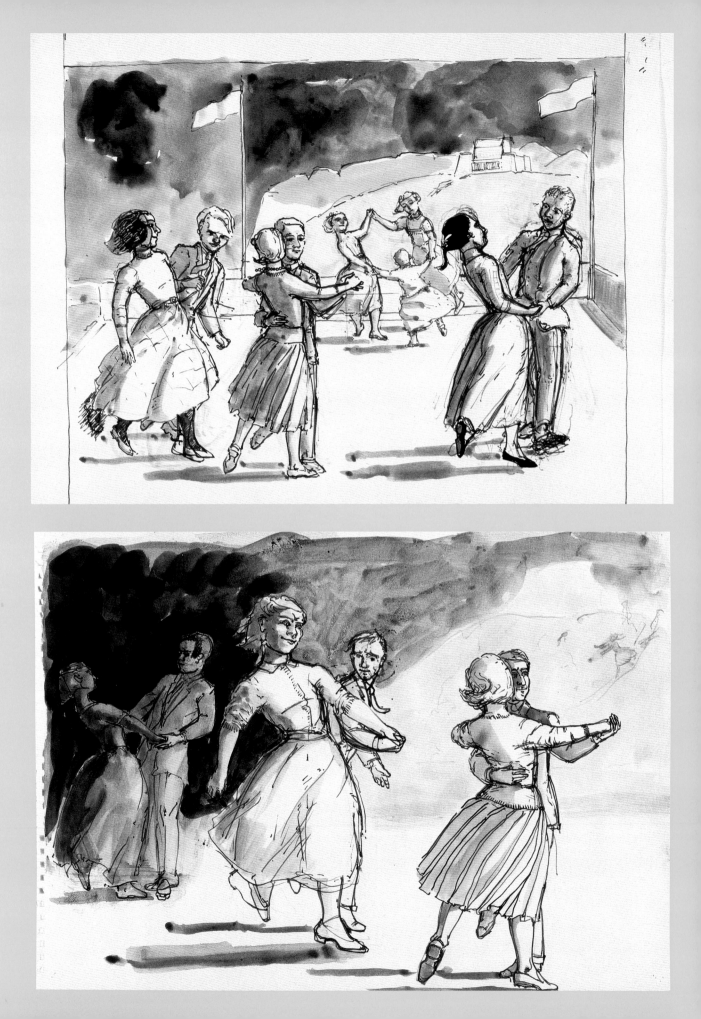

LITTLE MISS MUFFET 1989 [38]
Etching
52 x 38 (20½ x 15)

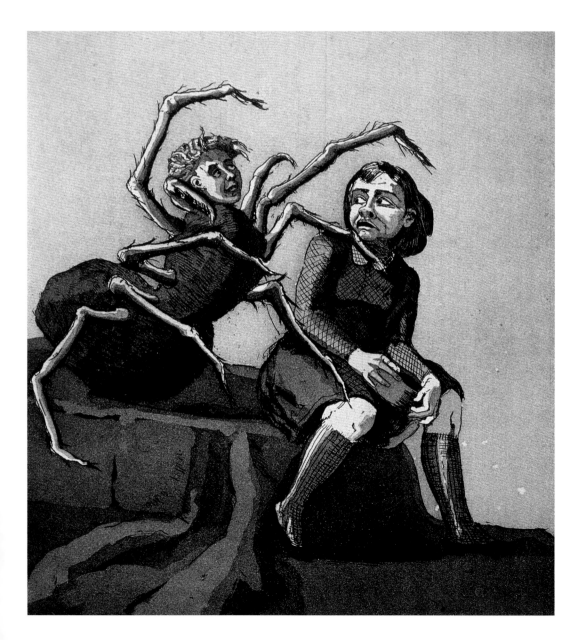

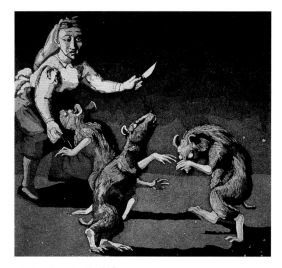

THREE BLIND MICE 1988–9 [39]
Etching
52 x 38 (20 $\frac{1}{2}$ x 15)

4

PRINTMAKING

The Dance took Rego six months to get right and, when it was finished, the artist felt in need of a change of pace. She turned her attention to etching, a technique she had learned at the Slade, and has practised periodically ever since, first on a small press she had at home in Portugal, and more recently in professional print studios. Seeking an escape from the elaborate rituals of painting, Rego began working with artist and printmaker Paul Coldwell, with whom she has since collaborated on several suites of prints, making them both as a complement to and an escape from whatever is going on in her painting.

Rego finds printmaking extremely satisfying, not only as an antidote to painting, but as a means by which images may flow thick and fast from her mind. She has a facility for it, drawing straight onto the plates and dealing easily with the fact that the image she makes there is the reverse of the one she will eventually produce. She finds that she has a tendency to compose in both positive and negative whether painting or printmaking, often using a mirror to check the spatial rhythms of a painting as she works on it. Making prints is a process that moves backwards and forwards between the creative and the mechanical, the unexpected and the inevitable, and this appeals to Rego, who thinks of it as an experience to which she may surrender images she can see in her mind's eye, curious to discover what will happen to them during the course of the printing process.

Etching is the method of printmaking with which Rego naturally feels most affinity, producing rich and complex prints which rely for their effect as much on the subtle manipulation of light and shade as they do on her characteristically energetic line. The process begins with line, with the artist drawing in a variety of implements onto wax spread on a pre-prepared copper plate. Once she is happy with the drawing, the plate is submerged in acid, the lines bitten into the copper, the plate inked and a proof taken. Though reversed, the process so far is positive – the image results from the lines Rego has drawn, with the spaces she leaves between them untouched by the ink. The next stage, however, is worked in negative, as aquatint – powdered rosin – is used to create varying degrees of shadow. Rego uses varnish to cover the parts of the image that are to remain unshadowed, then aquatint is applied to the plate, either hand-shaken or using an aquatint box. The plate is then heated, fusing the rosin onto the surface of the plate. The tonalities from white through to black can then be created by submerging the plate in acid; the longer in the acid, the deeper the etch, the darker the tone. To create the range of tones, the plate is repeatedly dipped in the acid for varying lengths of time, with areas being stopped out with an acid-resistant solution to preserve each level of tone, the artist keeping a map of the desired end result in her head. The plate is then cleaned, inked and a proof taken on damped paper. Aquatint is a very fluid process, allowing the artist to rework the image, change the drawing and completely revise the tonal values until the desired effect is achieved. Goya was the first major artist to use aquatint in printmaking, and Rego's profoundly atmospheric etchings owe much to his manipulation of the medium.

The first major series of etchings on which Rego embarked was a suite of nursery rhymes (1988), the idea coming to her from a book of illustrations she made as a present to her two-year-old grand-daughter Carmen. Familiar with English nursery rhymes from her own childhood, the artist found them a rich source of inspiration, images for each rhyme either existing already in her mind, or coming to her on waking, having read a rhyme before going to sleep in

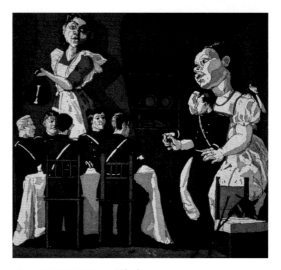

POLLY PUT THE KETTLE ON 1988 [40]
Etching and aquatint
52 x 38 (20 ½ x 15)

right: CAPTAIN HOOK AND THE
LOST BOY 1992 [41]
Etching
64 x 51 (25 ¼ x 50 ⅛)

the hope of finding inspiration in the night. Although she read a couple of studies of nursery rhymes, and is interested in them as vehicles for the unconscious hopes and fears of children, Rego's main motivation in working with them was as an immediately rich source of imagery in their own right, the terrors and consolations they hold easily available from the rhyme itself.

The visual ideas which crowd the *Nursery Rhymes* series of prints are the result of the traditional verses working directly on the artist's imagination. Many of the illustrations are intensely memorable interpretations and re-interpretations of the rhymes, the dynamics they set up between word and image staying in the viewer's mind to affect all subsequent encounters with the subject. *Little Miss Muffet* (fig.38) is simple in its powerful effect, the spider given uncannily horrible form by the addition of a human face, modelled on the artist's mother. *Three Blind Mice* (fig.39) takes as its subject the extreme, if usually submerged violence of the rhyme, the matronly housewife wielding an evil-looking knife in hot pursuit of the mice, who stagger blindly around her, a couple of their tails already reduced to stumps. The artist spins a rather more elaborate story around *Polly Put the Kettle On* (fig.40), towering two enormous girls over the figures of six soldiers who are, observes the artist, 'supposed to be chocolate soldiers', thus putting a rather sinister spin on the rhyme's last line – 'they've all gone away'.

Other series of prints have followed the *Nursery Rhymes* throughout the artist's career. In 1992, she was commissioned by the Folio Society to produce a suite of fifteen coloured etchings and aquatints to illustrate *Peter Pan*, a commission the artist accepted largely because she relished the chance of re-interpreting such an English classic. She found it harder

than the *Nursery Rhymes*, the images taking longer to come to her in her re-reading of the story. Yet she created many equally memorable images: the brooding quietness of *Wendy Sewing on Peter's Shadow*, a moment of almost Jungian intensity; the combination of airy achievement and concerted effort of *Flying Children* (fig.42), the forms modelled on Titian; the savage determination of the *Mermaid Drowning Wendy*. Most surprising and perhaps most effective of all is the artist's characterisation of Captain Hook as a sad, almost kindly figure (fig.41), an old man mourning the lost insouciance of his Pan-like youth, perhaps. We see him cradling a lost boy on his lap, his hook used to caress rather than threaten; we see him clumsily jousting with Peter, his heart clearly not in it; and we see him with Wendy, a caricature of a chivalrous gent rather than the pantomime villain we may have come to expect.

Both the *Nursery Rhymes* and *Peter Pan* are etchings produced to illustrate well-known stories longloved by the artist. More recent series of prints have been made from different kinds of material, and with different aims. Among the most successful is *Pendle Witches* 1996, a series of twelve etchings made to accompany poems by Blake Morrison, a project on which Rego collaborated with the writer in an intense exchange of ideas. He brought her the poems; she produced images for them, and at the same time offered him new material to think about, notably the traditional story of the 'Children's Crusade', which he used to great effect in his book *What If* (1997). *The Pendle Witches* is a sequence of closely-observed women, from the brave *Moth*, steadying herself for love, to the hags at the swimming pool who watch a young girl, 'shy and uncomeatable', caught in the spotlight of the artist/poet's vision. The visual images complement and extend those concocted in the words,

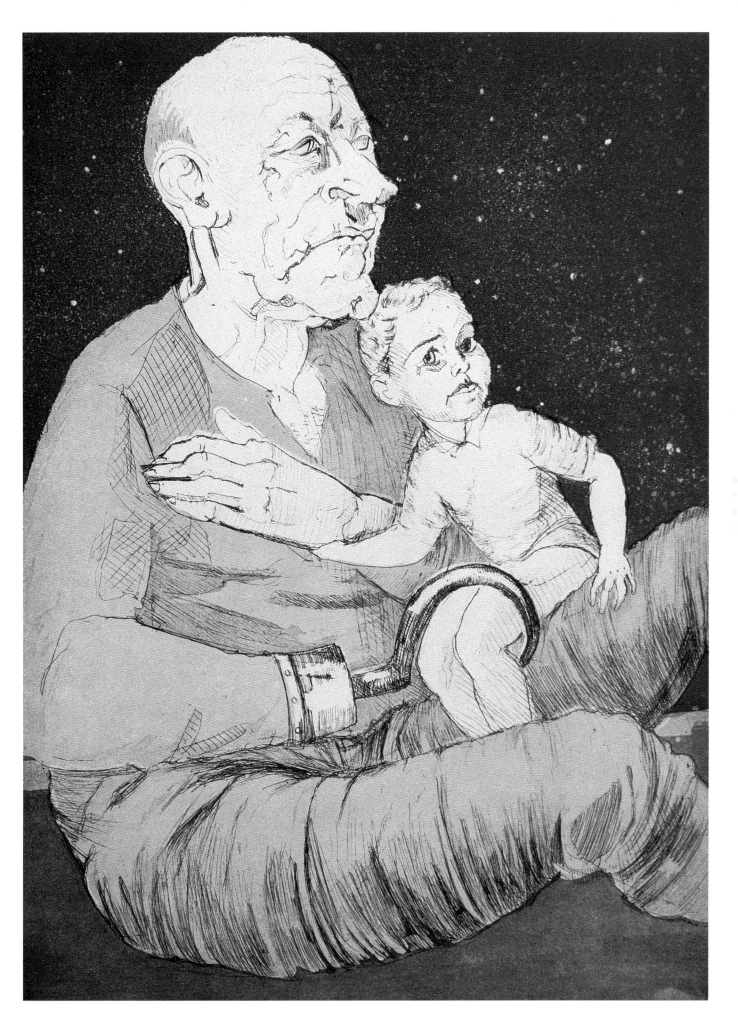

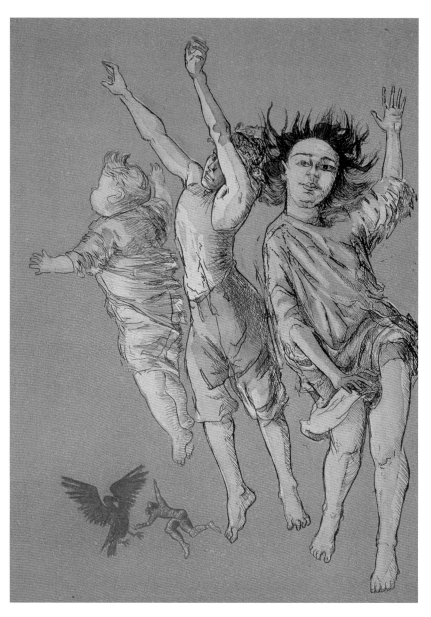

FLYING CHILDREN 1992 [42]
Etching
64 x 51 (25 1/4 x 20 1/8)

Rego giving a face and form to the nameless *Him*, for
example. In the poem, he is 'Like an arctic fox snap-
ping up grounded guillemot chicks / he hangs out in
the parks and wastegrounds, the id of cities, / for time
to bring her to this pretty pass'. In the etching, he is a
skeletal wolf man, preying on a girl in a back alley,
forcing her up against the dustbins to bite at her
breast.

Rego's prints punctuate her work. Most recently
she has made them with overtly political and propa-
gandist aims, in the spirit of satirical artists such as
William Hogarth, whose desire that his message
reach as many people as possible through prints made
of his work strikes a chord with Rego. In 1998 she
made a series of etchings after a sequence of paintings
on the subject of abortion. The paintings are looked at
in chronological sequence in a later chapter, but it is
worth noting here Rego's unconventional approach to
making etchings after her own paintings. Knowing
that the paintings in the series would be sold and split
up in collections around the world, and wanting to
retain a sequence of images that could be exhibited
together (the series was painted for the express
purpose of demonstrating a political and humanitar-
ian point), Rego made etchings after them. Rather
than simply copying the paintings, however, or
having someone else do this for her, as Hogarth well
might have done, Rego re-staged the situations of the
paintings, asking her models to sit for her again so that
she could re-imagine the scenarios from scratch. This
process results in extremely fresh, powerful images,
whose impact is derived from their understanding of
their status as etchings. Much harsher than the paint-
ings, they are also less ambiguous in the statement of
their subject, the literally graphic style leading to a
metaphorically graphic presentation of the visual and
social points they have to make.

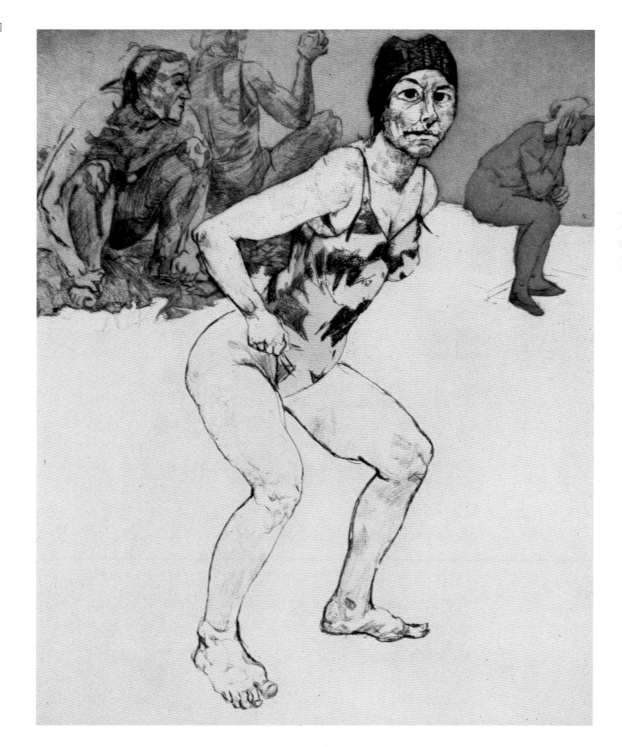

Rego has worked with artist Paul Coldwell to make prints since 1984. The collaboration has become an important part of both artists' practice. Recently, Coldwell spoke about working with Rego, and about a favourite one of her prints:

Our relationship goes back to 1984, when we did a series of prints of girls and dogs. Paula had done some printmaking at the Slade, but nothing really substantial. Charlotte [artist Charlotte Hodes, Coldwell's wife] and I went down to see Paula's show at the Arnolfini in Bristol, and I was very impressed. She was Charlotte's tutor at the Slade at the time, and I remember asking her if she had ever thought about making prints. Then she was asked to make one for the Royal College, and came to me to see if we could work together on it. I had never worked with anyone before, but we discovered a very productive relationship almost immediately. I'm not particularly interested in the technical aspects of printmaking; I don't see it as anything other than a way of bringing an image into the world, and that suited Paula. Neither of us gets excited about the various stages you go through – they're just a means of getting at a drawing.

It's not strictly a collaborative process – I'm a bit nervous of that term. When Paula comes to work with me, she's the artist, and my role is more like that of a midwife. I'm very clear about that. It's not a position I'd like to be in all the time, and I don't work in this way with anyone else. But I like it with her. It's a very particular relationship, which provides space for ideas to bounce around. Over the years, we've got into each other's heads, and I can anticipate what she might want, but in the end, the decisions are hers, and it's her name on the print. I think ours is just one of the relationships that structures her practice – she works through relationships with models, with the Marlborough, with certain writers and curators. They all enable her to do different things.

The first prints we made together, the girls and dogs, were very raw. They had none of the professional lustre that a printmaker will often impose on an artist's work. This was partly because Paula was interested in retaining the earthiness and urgency of the drawing, and partly because we were both on an incredibly steep learning curve. I didn't even have an aquatint box at that stage – we were shaking the rosin through a pair of Charlotte's tights!

Now we have a bit more of an established routine. At the beginning of a series, Paula will let me know what size of plate she wants to work on. I prepare them, and deliver them to her studio, where she works on them privately. When I next see them, the first drawing is in place. Often, it has already gone through a number of revisions – she starts in gouache, to give herself a fluidity before committing to a mark, and often even once a line has been drawn into the wax she'll paste it out and change it. Then we'll have a discussion about how the line

*should be etched, to what depth, how dark it should be, whether there needs to be much differ-
entiation from one part of the drawing to another.*

*Once we've etched the line, we'll take a proof, see if any alterations need making to the
line, make them if so, and then decide what kind of aquatint to work with. I put it on, and then
Paula will work through the tones, moving from light to dark. At this stage, she's generally
working on at least two or three plates at a time – it's incredible how she can keep a sense of
each one in her head.*

*Once Paula has finished the aquatints, we'll take a proof, and it's then that the real work
begins. It is extremely rare for the image to be correct at this stage. In some dramatic cases, all
the aquatints need to be polished off the plate and we start again. Some images are resolved in
a single day, others take four or five sessions. Quite often, we end up putting another ground
on the plate, and Paula will take it back to her studio to work on it some more – if she needs
more information from the model, for example.*

*Although it might seem laborious, Paula doesn't find the printmaking process frustrating.
She has absolutely no fear of it, and thinks nothing of risking everything. Other artists might
stop when they have something quite good, for fear of losing what they have, but Paula will
always sacrifice the good in the hope of something better. I think it might be because the whole
process is so clearly rooted in drawing, which is right at the heart of her entire practice, and so
she feels utterly at home with it. She uses the stages of printmaking in a theatrical way, with
the drawing as the first draft of the play. It may change a little as rehearsals progress, but the
characters and composition are basically fixed – what changes is the emphasis, the atmos-
phere, the lighting.*

*Once Paula is satisfied with a plate, she goes home and leaves me to take some good proofs
calmly and quietly. It's impossible to make the final decisions in the chaos of the process itself,
so I take the proofs over to her studio, and she decides the last things – the colour of the paper,
the tone of the ink etc. She isn't precious about the paper, she just wants the best support for
the image.*

*Flood is part of a very powerful suite of prints. They're ambitious in terms of scale, and
from print to print they encompass a broad range of imagery, from line drawing through to
almost painterly passages of aquatint. This particular print is very bold in terms of composi-
tion – it's quite radical to stick the girl absolutely in the middle of the composition like that, to
set her up like a dart board. The print has a curious sense of scale that Paula often uses in her
prints. She's exploiting the edges of the print in relation to the centre, and creating an
awkwardness between the two. The poor girl is too big for the plate. She's squeezed into the*

FLOOD 1996 [44]
Etching
67 x 52.5 (26 3/8 x 20 5/8)

tub, and then into the plate. She's got her skirts all messed up; she's not at her best. She's just trying to stay afloat.

And then there are all these other stories going on around her, just floating past. The little rat, clinging onto a twig for dear life. The sheep, floundering around, and the strange hairy dog. Bits of furniture bobbing about – it's like something out of Bosch. The water is so dark, so oily, it seems to be concealing some dark secrets.

I love the freedom with which Paula uses the various languages of the print. From the linearity of the drawing to the rhythms of the aquatint, playing the girl off against the water. The rain was added right at the end, with Paula scraping hard into the aquatint. Her control of the aquatint is amazing – to make all those eddies and swirls, to keep the patterning of the water in her head as she worked through each stage from white to black.

Having said that, it still isn't a virtuoso performance of printmaking – as a print, it's actually quite simple. The complexity is all in the drawing. Yet it clearly is a print, and was designed to be one. Paula loves the physicality of prints, the fact that the plate is pressed down onto the paper to release the image. And also, drawing with a needle on a resistant metal surface brings out a different quality in her work, a different sense of connection. I sense that she enjoys the material role that the acid plays – that a line can be made more or less aggressive. You put it in the acid for five minutes, and it looks as though a spider walked across the paper. Leave it for three hours, and you're practically through the metal, with lines so inky they're screaming at you.

I think that printmaking has played an important part in Paula's development as an artist. It has maintained a younger audience for her work, and it has made her imagery more widely available. She has played with the subversive tradition of prints, fully aware of their power to reach people and places that paintings don't. Her prints are all significant in their own right; they're not lesser versions of something that exists in a better form somewhere else. If you have one of Paula's prints you have the real thing – a story, complete in itself.

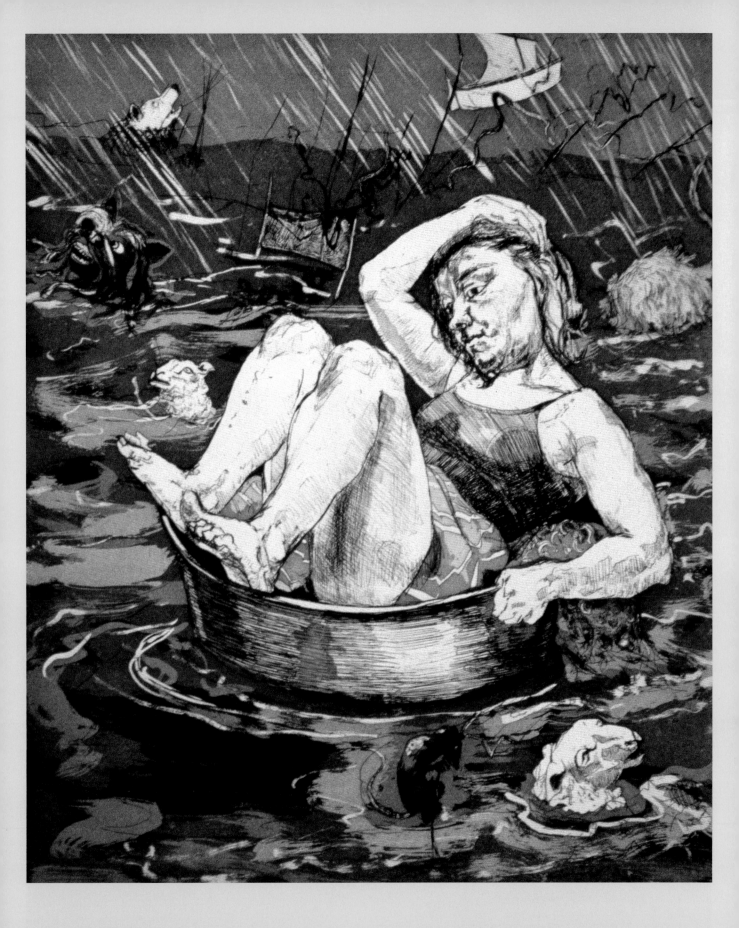

THE FITTING 1990 [45]
Acrylic on paper laid on canvas
132 x 183 (52 x 72)
Saatchi Collection, London

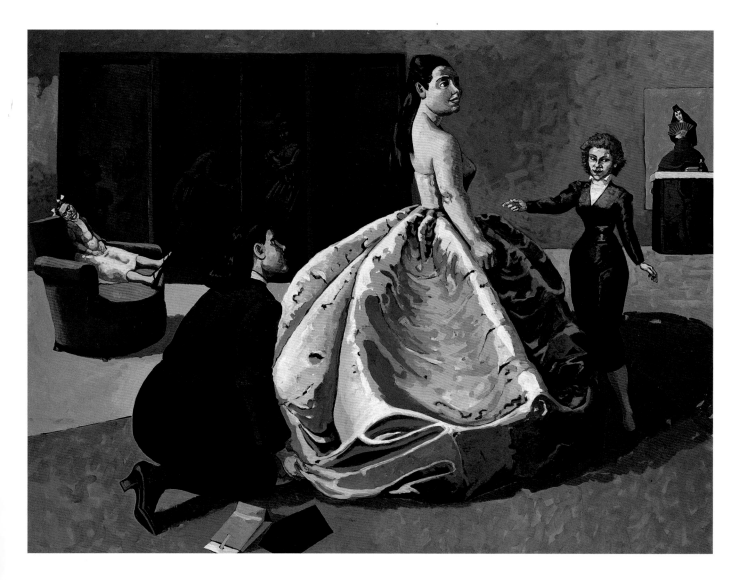

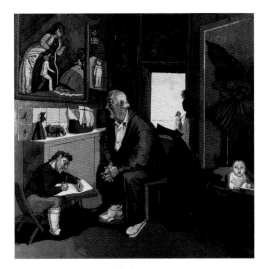

TIME PAST AND PRESENT 1990 [46]
Acrylic on paper laid on canvas
183 x 183 (72 x 72)
Gulbenkian Foundation, Lisbon

THE NATIONAL GALLERY

In 1990 Rego was appointed the first Associate Artist at the National Gallery, a post which gave her a studio for a year at the Gallery and required her to use it to make work directly related to the collection. A hugely daunting prospect for any artist, the residency's principal requirement unnerved Rego. She had always been a regular visitor to the National Gallery, and had close relationships with several paintings in the collection (notably Piero di Cosimo's *The Battle of the Lapiths and Centaurs c.*1500–15, a picture of the type despised by the Slade while she was a student there, but loved by her for its chaotic and transgressive vision of violence and love). Yet, despite her familiarity with the Gallery, it took her a while to find a way into the collection as an Associate Artist. Eventually, and perhaps typically, she managed it through stories, specifically those of *The Golden Legend*, written by Jacobus de Voragine from 1260–75, a book of lives of the saints which was widely used as a source book by the Renaissance artists whose work is in the National Gallery. The staff of the Education Department of the Gallery gave Rego a copy of *The Golden Legend*, and she found that with it she was able to make connections with the artists in the collection through a shared love of stories and interest in the best way to communicate them in visual art.

The first two paintings associated with Rego's residency at the National Gallery are *The Bullfighter's Godmother* and *The Fitting* (fig.45), although the first was not in fact painted at the Gallery, and the second was only finished off there. However, *The Fitting* does show some influence of works in the collection (critics have detected evidence that Rego was looking at Jan Steen's *The Effects of Intemperance c.*1663–5 while painting the large dress which is the focus of the picture, although the artist herself speaks of cabbages as her main visual reference). The paintings clearly make a pair. Both are family pictures, and involve sacrifice and self-effacement. In *The Bullfighter's Godmother*, a woman sends a young man out to seek his fortune while a young girl, clearly out of the action, passively watches. In *The Fitting*, a debutante is prepared for her entrance into society, the mother showing off her daughter, making her look in the mirror in an attempt to give her some confidence. Kneeling on the floor, adjusting the hem of the gown, is the dressmaker, whose own daughter sits, crumpled and doll-like, in the background. *The Fitting* is full of clearly-recognisable Rego types – the acquiescent, cow-like girl, the huge and helpful dressmaker, the tiny, pushy mother, the overlooked girl. It also contains several pictures within pictures, which both look back to the commentating devices used in earlier works such as *The Family*, and forward to future paintings in which the artist tackles head-on some of the pictures in the National Gallery collection. The pictures within pictures function as a commentating device, speaking overtly of the sacrifice which is the main picture's covert subject. Thus the screen shows Satan in the form of a literally pig-headed woman, trying to snatch a baby away from its mother. A fable invented by Rego, this scenario neatly parallels the situation in which the girl on whom the dress is being fitted finds herself – being prepared to be snatched away from her home into the material world of the marriage market.

Time Past and Present (fig.46) was painted entirely in the studio at the National Gallery. Asking an old friend to pose as St Jerome, the familiar, scholarly saint usually depicted in Renaissance imagery either in his study or praying in the wilderness, Rego surrounded him with painted memories which take the form of pictures, some copied from the Old Masters of the collection, some invented. She retained

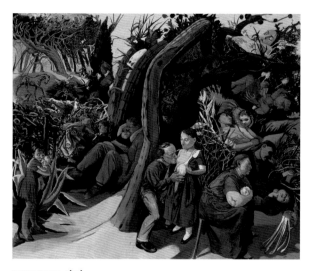

CARITAS 1993–4 [47]
Acrylic on canvas
200 x 240 (78 3/4 x 94 1/2)
Saatchi Collection, London

the academic context most often associated with the saint – the room is strongly reminiscent of a wood-panelled don's study at an Oxbridge college – and adds a whiff of the wild by making her subject an old sailor whose mind, and room, opens out to the sea.

Rego's sailor is babysitting, and the right-hand side of the painting has something of the Annunciation about it, with Rego's invented angel swooping down towards the baby who has been left in the old man's care. This theme is picked up again in *Joseph's Dream* (fig.48), which shows a female artist at work on a version of Philippe de Champaigne's *Vision of St Joseph* c.1638, an angel dropping in as a champion of the creative process. The image of the artist is a recurrent one in Rego's practice, painted painters facing their subjects as we imagine the real artist to have faced hers. From *Red Monkey Drawing* of 1981 to *Martha* 1999, these images crop up sporadically, never quite self portraits (although Rego referred to herself in comparison with Willing, in a recent monograph on her late husband as 'the monkey with the typewriter'), but nevertheless offering both artist and viewer a way into the painting.

Joseph's Dream is a picture about picture-making, and the process it describes is not unlike Rego's own. Like Rego, the painted painter has made a series of preparatory drawings, trying to work out from what angle best to tackle her subject before beginning to paint. Having done them, she has now discarded them, preferring to work again from life directly onto the canvas, building up the picture character by character rather than squaring up or faithfully copying a final drawing. The painting is obviously set in an artist's studio and, given the overt references it makes to a picture in the collection, is possibly about Rego's sense of her own position as an artist with a studio in the heart of the National Gallery. Perhaps taking her

revenge on the overwhelmingly male artists in the Gallery, Rego reverses the usual gender roles of artist and model, rendering the man rather than the woman vulnerable to the gaze of both artist and viewer. The male model may be fully clothed, as his female counterparts seldom are, but he is asleep, and therefore not in control of the representation of which he is the subject.

The best-known and most spectacular of Rego's National Gallery paintings is *Crivelli's Garden* (fig. 52, pp.64–7), the large, three-panel mural commissioned by the Trustees for the new Sainsbury Wing Restaurant. The subject of the painting is the life of the Virgin Mary and other female saints. Rego had already completed a large drawing on the subject of the life of the Virgin when she was invited to paint the mural, and added the other saints and mythological heroines in homage both to the National Gallery's collection (all the women who appear in the mural appear in paintings throughout the collection) and to her own way of engaging with it (the lives of the women are all also featured in *The Golden Legend*). The painting takes its title from Carlo Crivelli's *Madonna della Rondine* (after 1490), the predella of which shows saints in a garden whose wonders can scarcely be glimpsed.

Rego's reworking of the classic Christian subject of the Virgin Mary surrounded by saints concentrates on the women's humanity. Mary and the saints were real people, and the mythological characters who appear alongside them are their equivalents or forebears. Rego's women, whilst depicted, as tradition demands, with the attributes that attest to their sanctity, have a reality and solidity to them that is unusual in religious painting. Rego's Martha sweeps while her sister Mary Magdalene sits and dreams. Her Judith worries very humanly about how to conceal the head of Holofernes whom her destiny dictates she must decapitate. Her

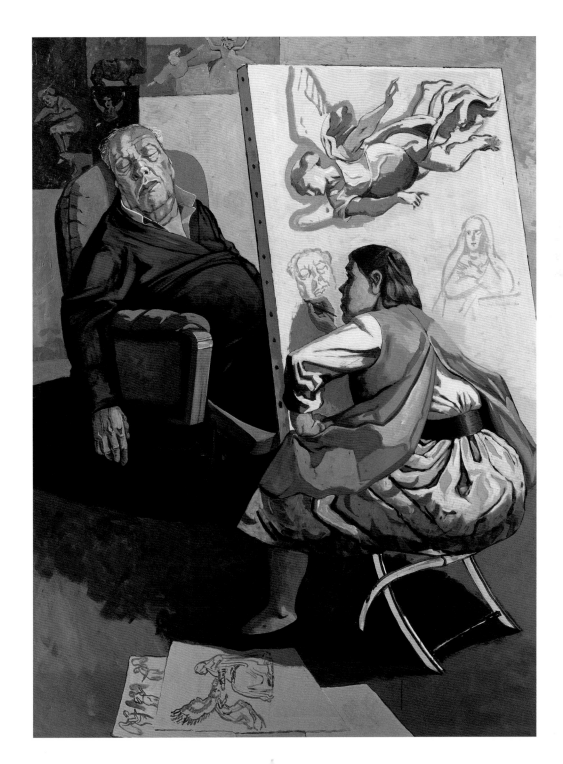

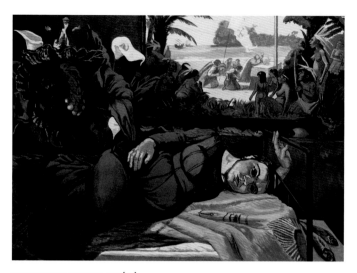

THE FIRST MASS IN BRAZIL 1993 [49]
Acrylic on canvas
130 x 180 (51 1/8 x 70 7/8)
Private Collection

Mary and Elizabeth seem more like ordinary women meeting to share a secret than the protagonists in the biblical drama of the Visitation.

The Virgin Mary's particular combination of humanity and divinity is a subject to which Rego has recently returned. Commissioned to paint the life of the Virgin for a chapel in Portugal, she has produced eight small pictures, extraordinary in their ordinariness, of the artist's vision of Mary as a young girl who, in Rego's own words, 'has had the misfortune to get herself knocked up'.

Making such a major painting in the essentially Christian context of the National Gallery's collection was something of a turning point for Rego. Fascinated as she is by iconography, and by the history of visual story-telling through the use of particular types and tropes, *Crivelli's Garden* offered her the opportunity both to adopt and adapt Christian pictorial norms. In the past, Rego had used elements of Christian iconography to underpin her compositions or had structured paintings according to patterns familiar from the Christian canon. In *Crivelli's Garden*, however, as in the new life of the Virgin, the Christianity of the iconography is all out in the open, and Rego delights in both conforming to and confounding expectations. This is clearest in the doubled figure of Mary Magdalene, a particular favourite of the artist. The biblical bad girl is shown once pensive and mourning, and once scholarly and, crucially for Rego's sympathy with her, sexy, with winged angels pressing up between her legs, ready, so the artist insists, to shoot her up to heaven for a good meal. Mary Magdalene reappears periodically throughout Rego's work from this point on, either – as here – as herself, or else in disguise, lending her particular air of quiet and self-sufficient desperation to a succession of finely observed, solitary young women.

Unusually for Rego, *Crivelli's Garden* obeys the laws of pictorial perspective, with a consistent floor level and horizon line anchoring the depicted space so that all the figures have their feet firmly on the ground. The artist felt this to be necessary to keep such a large painting together, but her desire to use perspective may also be linked to her study of the pictures elsewhere in the Gallery. However formally conformative the mural might be in comparison with, for example, *The Proles' Wall*, Rego's other enormous mural painting, the use of perspective does not limit the artist's inventive variations in scale. Calling perhaps on older traditions of painting, in which the perspectival system of the Renaissance was not yet at work, she mixes important, large-scale characters with smaller commentators on the action, in a method highly reminiscent of *The Proles' Wall* and her opera series of paintings.

Again recalling early paintings, Rego's choice of colour in *Crivelli's Garden* is extremely restricted, limited to blues, greys and browns. This is partly because of the picture's location (the artist speaks of wanting the painting to blend into the walls, like wallpaper, of not wishing to use lurid colours which might put people off their food). It also makes reference to the tradition of tile painting, extremely strong in Portugal and very familiar to Rego. The techniques of tile making demand a restricted palette, with blue the dominant colour. Much of the explanatory action in *Crivelli's Garden* takes place in painted tiles.

The paintings Rego made immediately following her residency at the National Gallery were large and complex, and made use of the wealth of iconographic material she had studied during her time working among the collection. Many of them were shown in the Hayward Gallery exhibition *Unbound:*

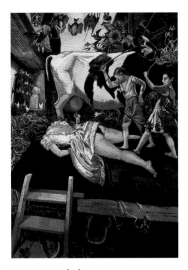

THE BARN 1994 [50]
Acrylic on canvas
270 × 190 (106 1/4 × 74 3/4)
Berado Collection, Sintra Museum
of Modern Art

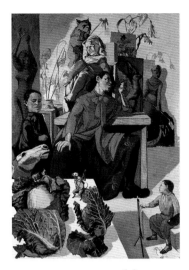

THE ARTIST IN HER STUDIO 1993 [51]
Acrylic on paper laid on canvas
180 × 130 (70 7/8 × 51 1/8)
Leeds City Art Gallery

Possibilities in Painting of 1994. *Caritas* 1993–4 (fig.47) abandons the perspectival organisation of *Crivelli's Garden* to pile into the canvas successive examples of different types of love (or charity, as in love's biblical incarnation). Mothers and sons, fathers and daughters, brothers and sisters, and several pairs of lovers swirl around the central pair of figures, in whose suckling gesture all forms of love, both natural and transgressive, seem to collect. There is a tangled claustrophobia to both the painting's woodland setting and the jumbled figures within it, which is also present in *The First Mass in Brazil* 1993 (fig.49) This uses the device of the picture-within-a-picture to provide a context for the misery of its pregnant central character. Against a background of the Christian church 'civilising' the heathen, the girl lies as some kind of parallel sacrificial offering, an alternative host. Her helplessness is matched by that of the dolls on the shelf behind her, the fish that lie next to her (and perhaps also the turkey, although his primary function seems to be to add visual splendour to the composition), all the pictorial elements building tension around the depicted Eucharist to create an atmosphere of transfigured consumption and death.

The cycle of paintings completed on leaving the National Gallery also includes *The Artist in her Studio* 1993 (fig.51), something of a summary painting, which incorporates several pictures within pictures as well as two painted painters – a young girl at an easel and a mature, pipe-smoking artist. The culmination of this series, however, is the vast and impossibly complicated *The Barn* 1994 (fig.50). A picture teeming with oppressive, inexplicably sinister detail, it relates to a short story by Joyce Carol Oates called *Haunted* (1994), which impressed itself on Rego's imagination at the time of the picture's making. The story, told in

the first person, concerns the childhood memories of an adolescent girl called Melissa. Mixing fact and fantasy, the memories circle around an old abandoned farm, out of bounds to the narrator and her childhood friend, but irresistibly fascinating to them. Visiting it together and alone, they have a series of strange and scary experiences in the old house and barn. Strong sexual undertones run throughout the story, which culminates in Melissa being beaten by a woman who discovers her in the abandoned house, and her friend being found murdered several days later. The story is in a collection of 'Tales of the Grotesque' by the same author, and this experience of the literary grotesque fuelled Rego's abiding interest in popular forms of visual expression, adding a further dimension to her fascination with caricature and cartoons. The forms in *The Barn* flirt with the grotesque in a way that Rego picks up in later work, the deliberate clumsiness of the painting process mirroring the crudeness of the activity and emotion depicted.

Rego remembers her time at the National Gallery with great pleasure, much of which is focused around the mural painting she made for the Gallery's new restaurant at the request of Caryl Hubbard, one of the Trustees. There is an extensive interview about the process of making the mural in John McEwen's monograph of Rego, and recently the artist spoke of the mural again.

PAULA REGO I made it as a testament of my admiration for the National Gallery, and the honour I felt at being asked to work there.

FIONA BRADLEY Did you feel like an outsider there?

PR Yes, but not in a bad way. Everybody is an outsider to the National Gallery – there can't be anybody in the world who feels that their work comes close to the stuff in there. We're all outsiders. I knew that I couldn't approach the paintings there through trying to make a stylistic painting that would match up, so I went in through stories, through the stories in *The Golden Legend*.

FB Did you find the criteria for the residency hard? The fact that you were asked specifically to make work which responded to the Gallery's collection?

PR No, I don't mind being given things to do. I like it. I like being commissioned. Like when Philip Dodd asked me to make work for the Hayward's *Spellbound* exhibition, about film. It starts me thinking in a new way. Being asked to make work in response to the National Gallery, it's like a fairy story – you have to sit up all night and spin straw into gold or something like that. It was like being given a task, which is good.

FB Was *Crivelli's Garden* a site-specific commission – did you collaborate with the architect who was designing the restaurant?

PR Not at all. I knew that they wanted something for the restaurant, and roughly the size of the wall and so on, but I didn't know what the room was going to look or feel like. But I wouldn't have wanted to know much more – I didn't want to make a piece of design; it was not a decorative impulse I had. It was the conception of it that interested me, the idea of doing such a big picture. It was pure luck that the colours matched in the end.

FB What made you choose such a reduced palette of colour?

PR Well, it was based on Portuguese tiles. I thought that you shouldn't have lots of bright colours in a restaurant, because it's offensive and showy. In Portugal, the restaurants are all tiled, so that you can wash down the walls to keep them clean. So I thought I'd mimic that somehow, and make something that looked a bit like tiles. Because of the process of making tiles, the colours are reduced, so I used the colours you find mostly in tiles – blues and so on.

FB Did you ever think of doing it as tiles?

PR No, I couldn't have done it at the time – I wasn't asked, and I didn't think of it. The tiles came much later. So I did a normal painting, but with Portuguese tiles in mind.

FB Was there anything you changed in your way of working, in order to tackle such a large picture?

PR Not really. I loved the fact that it was so large, that it gave me such a big space to disrupt things

in. I thought of it as a chance really to send things up the spout. I could play with scale, try things out, mix things up. I started by reading the stories, all the women saints, and the life of the Virgin. Then I drew everyone I could find. There's a lot of my family in there, even myself from a photograph with Cassie when she was a baby; the woman who was looking after my mother; our au-pair at the time, friends, a famous art critic from Portugal, several of the staff of the Education Department at the National Gallery. It seemed important to use real people for these saints. I painted the pictures from the life drawings – I didn't ask people to sit again.

FB And did the pictures come easily?

PR Until the last one, which was really hard. I kept going and going on it, until eventually my friend Tilly said that I shouldn't throw good work after bad, and I should just start again. I was terrified, because I was running out of time, but I scrapped it. I went into the library, and Judy Edgerton showed me a picture of this wonderful Italian fountain. I copied that, and changed it, and it all took off from there. The fountain unblocked everything else. I put scenes from Aesop's fables round the bottom, and then story upon story into the background, before the figures came to anchor the whole thing.

FB Did it feel like a different process? To be making a public art work?

PR It was more pressurised. I wanted it to be good, and I was worried it wouldn't work. I was worried when I showed it to the architect, as the commission wasn't his idea. But he liked it. I fiddled with it a bit to make it fit the space – added the columns at the side to tie it all in with the space and into itself. But it didn't really feel like a mural, or a public art work, just a big picture. The moment I remember most clearly is when they came to take it out of my studio. They wheeled it through the National Gallery, and I was embarrassed and terrified. It wasn't the public seeing it I minded, it was the pictures. I apologised to each picture we passed . . . But I'm proud of it now.

CRIVELLI'S GARDEN 1990–1 [52]
Acrylic on paper laid on canvas
left panel 190 x 240 (74 3/4 x 94 1/2)
overleaf: right panel 190 x 240 (74 3/4 x 94 1/2)
Sainsbury Wing Restaurant, National Gallery, London

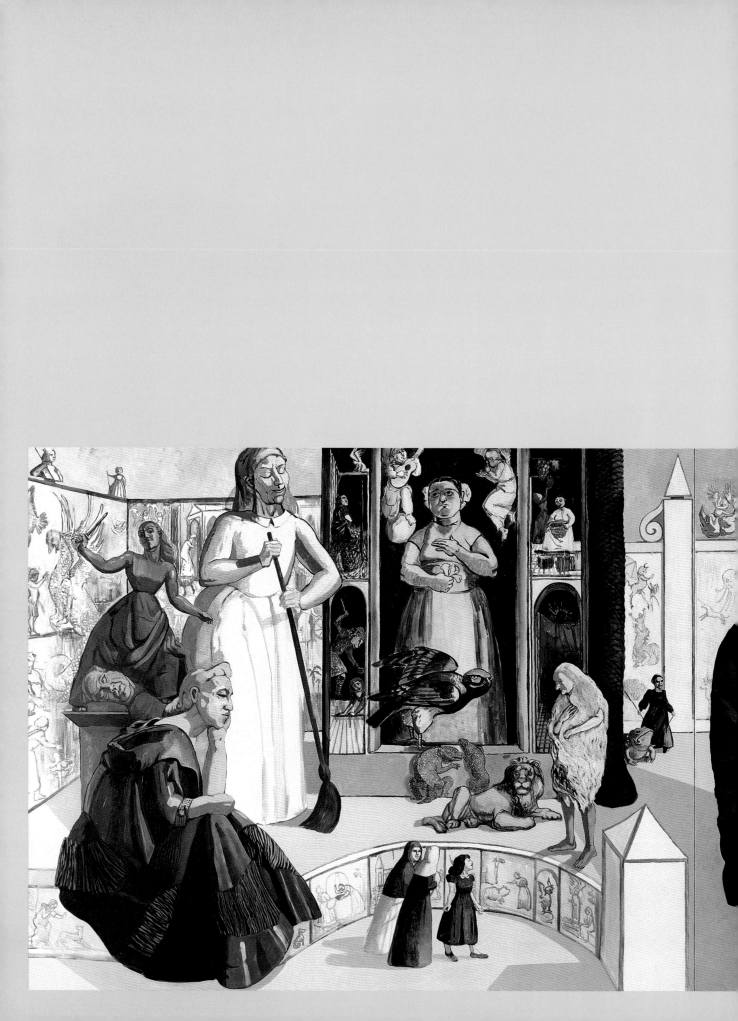

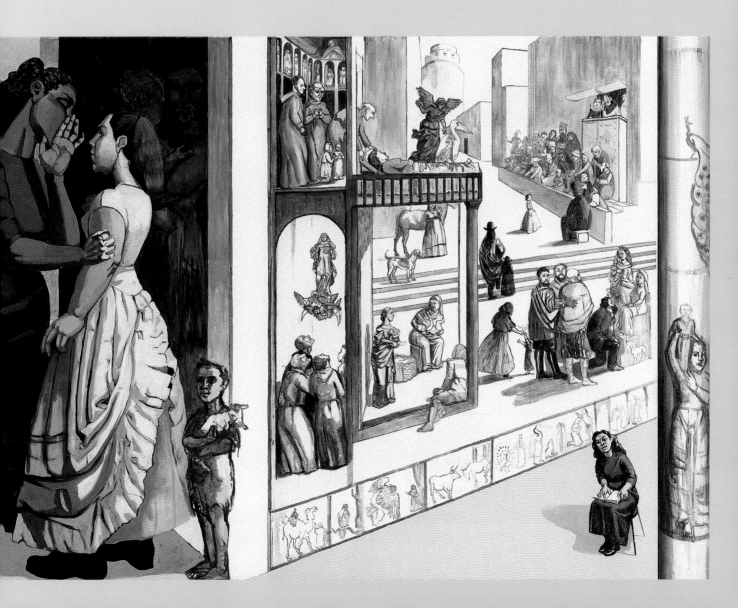

DOG WOMAN 1994 [53]
Pastel on canvas
120 x 160 (47 1/4 x 63)
Saatchi Collection, London

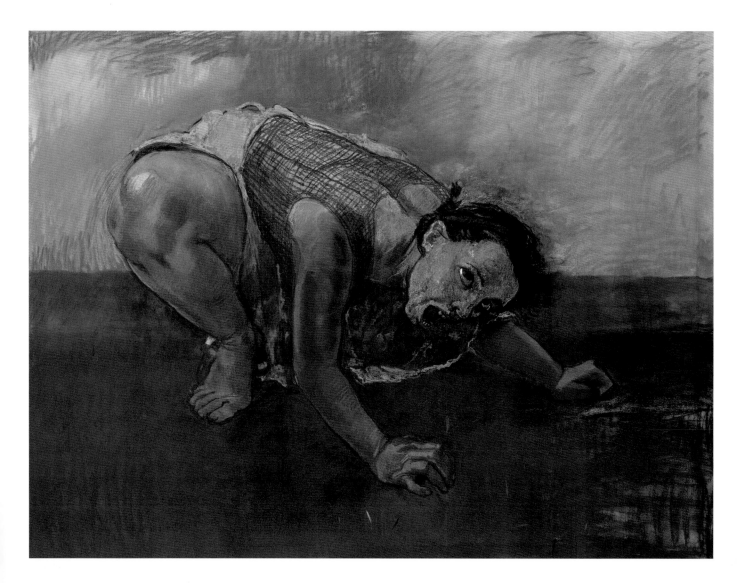

BAYING 1994 [54]
Pastel on canvas
100 x 76 (39 3/8 x 29 7/8)
Private Collection

DOG WOMEN AND DISNEY

The Barn marks the end of an era in Rego's painting. In 1994, immediately following *Unbound: Possibilities in Painting*, the artist embarked on a completely new cycle of work, in which fresh subject matter coincided with a change of technical direction as radical as the abandonment of collage in 1981. As then, the new technique involved a return to drawing as the primary means of artistic expression. *The Servant* 1994, one of the pictures in *Unbound*, was made in pastels on paper laid on aluminium. That picture itself is not one of the artist's most successful, but its medium excited her. Using pastels, she discovered a painting process which required much less translation from idea to execution and which enabled her, for the first time since she had stopped working on the floor, to become bodily engaged with the development of a picture. It was working from life which had stopped the artist using the floor; painting a model requires an easel, so that model and canvas may be seen at the same time. The combination of easel and paintbrush distances a painter from both subject and representation. Using pastels, however, Rego rediscovered something of the joy she felt when cutting up and reassembling her forms to make collage, or when drawing rapidly on the floor for the opera series of paintings. Working in pastel is similarly visceral, and making the forms is part of a process intimately connected to the artist's body. Pastel can be reworked immediately, with any random slips and smudges incorporated into the process. Like her work with collage, Rego's pastels owe something to her interest in the gestural automatism of Surrealism. Like the Surrealist artists, she was keen to find a way to link mind and hand with a process that might rupture the determinism that habitually reigns over the relationship between gesture and conscious thought.

Rego's use of pastels is somewhat unorthodox, and results in a kind of drawn painting. The first truly successful picture to use the new technique was *Dog Woman* (fig.53), the initial painting in a series made in 1994 which announced an abrupt change of scale, pace and focus in her work. Complex narratives worked out within a single canvas were temporarily abandoned in favour of female figures, alone or in pairs. Throughout the series, the figures are almost always unsupported, with only minimal backgrounds and few props. They make their meaning through the relationships they forge with each other, the artist and the viewer. The pictures are intimate, knowing, almost painfully revealing. As often in Rego's work, the series of women seem at once many women and all the same one. They are not self-portraits, but the marks of the pastel, their origin in the artist's fingers clearly visible, link the forms of the drawn women to the physical activity of their creation and creator.

Dog Woman, and the series that followed, are the result of a now-familiar coincidence of narrative and painterly experimentation. A friend sent Rego a story about a woman living alone in a house surrounded by sand-dunes, with only a houseful of animals for company. One winter's evening, driven mad by the isolation and the wind whistling through the dunes, which sounds to her like a child's voice, the woman gets down on all fours and devours her pets. This story of loneliness, disappointment and frustration returned to Rego during a drawing session when, casting about for something to do, she asked Lila to settle into a snarling squat. She drew the pose quickly, modified it later having tried out the pose physically herself to see what it felt and looked like, and recognised the resulting woman as a dog woman, heir to the woman in the story, who has lived a life and who carries her history and her familiars within her. Pastel

SCAVENGERS 1994 [55]
Pastel on canvas
120 x 160 (47 1/4 x 63)
Private Collection

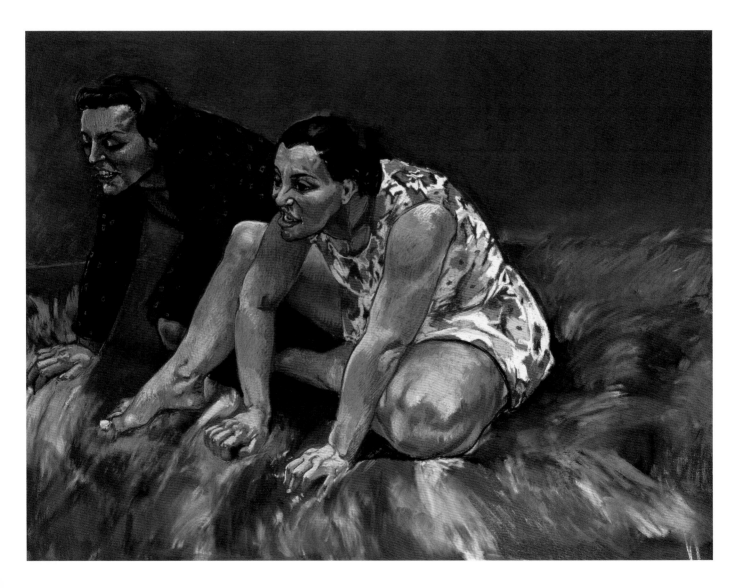

GROOMING 1994 [56]
Pastel on canvas
76 x 100 (29 7/8 x 39 3/8)
Private Collection

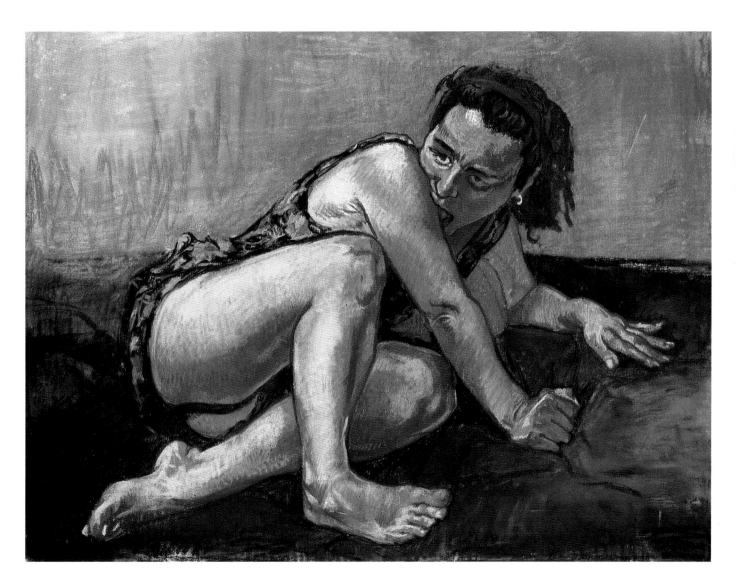

BAD DOG 1994 [57]
Pastel on canvas
120 x 160 (47 1/4 x 63)
Private Collection

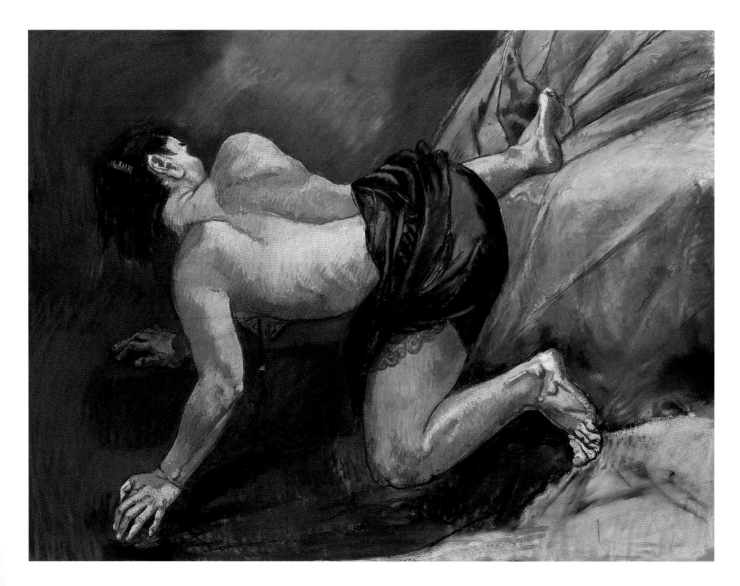

SLEEPER 1994 [58]
Pastel on canvas
120 x 160 (47 $\frac{1}{4}$ x 63)
Private Collection

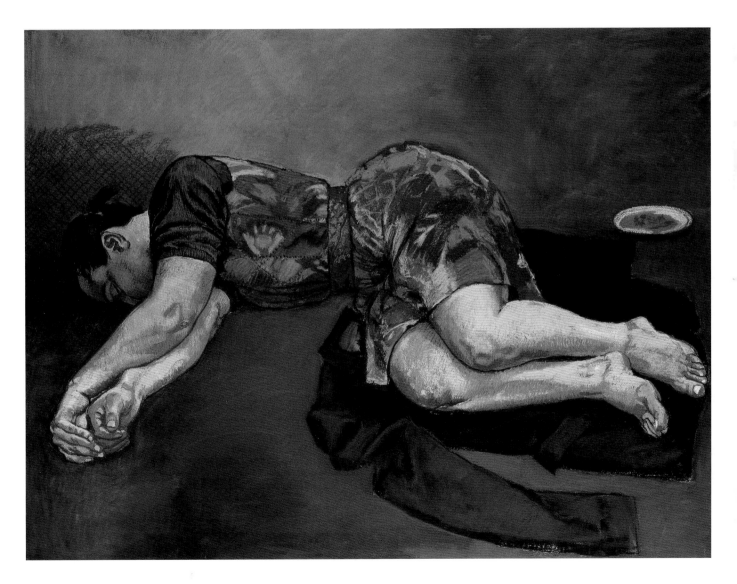

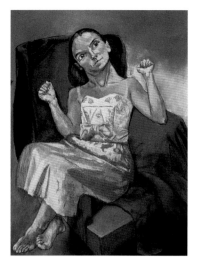

MOTH 1994 [59]
Pastel on canvas
160 x 120 (63 x 47 ¼)
Private Collection

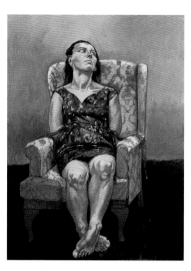

SIT 1994 [60]
Pastel on canvas
160 x 120 (63 x 47 ¼)
Private Collection

seemed the correct medium in which to perpetuate the existence of the dog woman, and the resulting painting, though intensely naturalistic, contains certain disparities of scale which direct and sharpen the viewer's response to the figure. Its points of focus, which make a triangle within the painting to rhyme with the triangularity of the pose, are the woman's left hand, open mouth and enormous knee. The painting's emphasis is on the woman's physicality, a strength and power gained through maturity. Inevitably, as a dog woman, she refers back to Rego's girls and dogs, although she is depicted as rather than with a dog, and she is certainly no girl. She has traded the previous girls' adolescent coquettishness and youthful uncertainty for the older woman's experienced and self-aware sexuality.

After the first, the following dog women came thick and fast. Sometimes they hunt in pairs, either waiting for food (fig.93, p.120) or going out in search of it. Their hunger is for food, for love, and possibly for revenge – *Scavengers* (fig.55) is a study in frustrated desire. Of the single figures, some are more dog than woman, and some vice versa; some are triumphant and some seem to have had their power beaten out of them. *Grooming* (fig.56) shares some of the unbridled sexuality of *Dog Woman*, the figure engrossed in an exploration of her own body. *Sleeper* (fig.58) nods at the presence of an unseen male, who may be the focus of the dog woman's attention as she sleeps on his jacket. Soon, however, in *Bad Dog* (fig.57), she is being kicked out of his bed for making a mess. Most of the dog women are messy, the realities of their ageing bodies responding well to the smudging of the pastel colours out of which they are made.

The dog women paintings are all of a similar size, with the occasional small one such as the desolate *Baying* (fig.54, p.69) providing a rhythmic counter-

point when they are all hung together. Three of them, *Moth, Bride* and *Sit* (figs.59, 61, 60), are more subdued than the others, the women keeping the dog in them rather more tightly in check. They form a kind of prelude to some of the more independently willful dog women, preparing themselves for, offering themselves to, and obeying their master. *Moth*, her name taken from a Blake Morrison poem, is a debutante dog woman, dressed up to flirt. *Bride* rolls over, puppy-like and acquiescent, her soft and vulnerable belly fatally exposed on her wedding day. In *Sit*, the belly is full of child, and the dog woman waits, bound and mute, biding her time.

The dog women, complex, mature, embarrassed and proud as they are, seem to direct Rego's work from the moment of their making, stalking many of her future subjects. In 1995, soon after finishing them, the artist was invited by Philip Dodd to participate in *Spellbound: Art and Film*, a group exhibition he was curating for the Hayward Gallery. Rego made a series of pastels loosely inspired by the dancing ostriches from Walt Disney's *Fantasia* (1940). Reversing the process whereby the animators researching the film drew women pretending to be ostriches in order finally to present them as ostriches dressed up as human ballerinas, Rego re-imagines Disney's ungainly, flightless birds as the original, no less ungainly women (figs.62–5). Rego's women are not real ballerinas, but older women remembering what it was like to be little girls dressed as ballerinas, all tutus, ribbons and bows. The pictures have much more to do with Rego's on-going project than with Disney – his ostriches, and Dodd's invitation, merely provided the artist with a set-piece framework in which to explore the new possibilities first shown to her by the dog women.

Hung together as one work, the eight pastels in the *Dancing Ostriches* series form a complete environ-

BRIDE 1994 [61]
Pastel on canvas
120 x 160 (47 1/4 x 63)
Tate

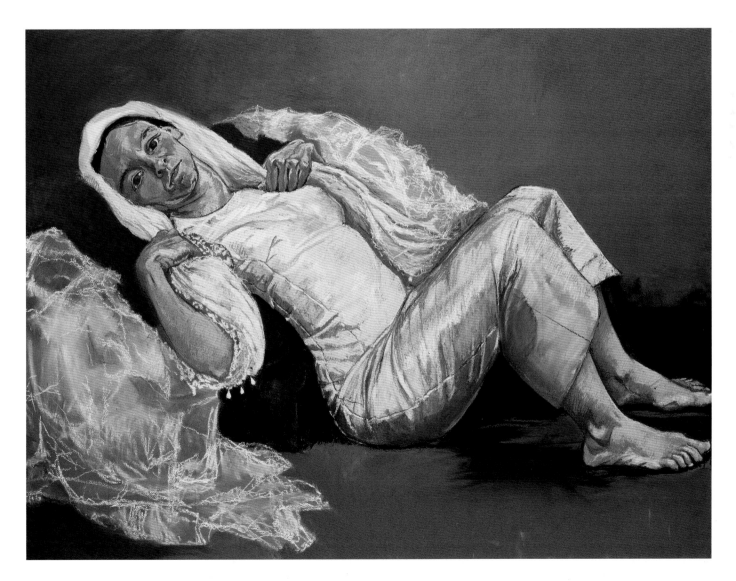

DANCING OSTRICHES FROM WALT
DISNEY'S 'FANTASIA' 1995 [62]
Pastel on paper mounted on
aluminium
Left panel 162 x 155 (63 3/4 x 61)
Right panel 160 x 120 (63 x 47 1/4)
Saatchi Collection, London

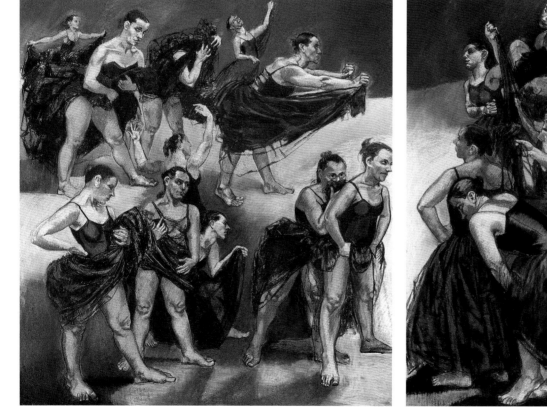
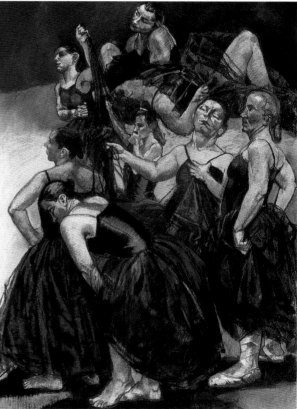

DANCING OSTRICHES FROM WALT
DISNEY'S 'FANTASIA' 1995 [63]
Pastel on paper mounted on
aluminium
150 x 150 (59 x 59)
Saatchi Collection, London

DANCING OSTRICHES FROM WALT
DISNEY'S 'FANTASIA' 1995 [64]
Pastel on paper mounted on
aluminium
150 x 150 (59 x 59)
Saatchi Collection, London

ment, a chapel of observed and represented femininity. Life-size, crammed into a predominantly square format, the women wait to perform for an audience. While the dog women were earth-bound, the ostriches, though very much of the body, have spiritual aspirations: poised on some kind of threshold, they articulate a liminal, expectant sensibility. As iconographic types, they run much deeper than the works of Disney, tapping into much older artistic and narrative traditions.

Fantasia presents ostriches pretending to be women, literalising and playing with the common metaphoric equation of woman with bird. Rego, in inverting the Disney fantasy, places her women back in the realm of the real – they may be representations verging on the grotesque, but they are not cartoon animations. She collects around them a proliferation of visual possibilities suggested by the associations they embody. Ostriches are said to put their heads in the sand rather than face up to danger or change. The tutus Rego's women wear as they prance and preen may be read on one level as an index of their refusal to face the changes brought about by age. Ostriches are flightless. As viewers, we do not share the confidence shown by Rego's women that they can get their impending ballet performance off the ground.

As well as ostriches, Rego's women also accept other metaphorical identities, and are perhaps most convincingly readable as variations on harpies. Mythologically the personification of dangerous storm winds, fabulous creatures with the body of a woman and the wings and claws of a bird, harpies are linguistically perpetuated as carping, frustrated old women. While the ancient, mythological anthropomorphosis was powerful and predatory, harpies are weakened by the contemporary metaphor. Real harpies prey on men; they exist to blow them off

course, not simply to irritate them. Rego's ostriches are perhaps wistful realisations of the contemporary metaphorical harpy, who remember the past power of their former, mythological status.

The ostriches plan their nostalgic flight from a world strewn with the trappings of the mundane and the domestic. They cavort on and around an old vinyl sofa; they pose uncertainly on a tapestry armchair. Some of these props are familiar from the dog women series, and represent a very different method of creating background context from the artist's earlier work. The bits of furniture are no longer remembered from houses in Portugal, or taken from paintings, or invented to serve a particular symbolic or supporting function. Rather, they are part of the scenery of Rego's studio, and are used literally to prop up her models as they pose. In the *Dancing Ostriches*, as in many other future paintings, the bits of furniture are used undisguised. They connect the flights of fancy initiated by the mythical and metaphorical women to the daily activity of their creator. The prominence of the props underlines the performative aspects of the ostriches' story, emphasising its staginess and artificiality while at the same time suggesting that a rather clumsy experimentation is embedded in their generation as well as their presentation. Their literalisation of word games is itself a refiguration of another kind of play – that of artist and model. If words and word associations can in themselves begin to suggest new directions, then so can represented and real bodies. Drawn directly in pastel from the model onto the canvas, the *Dancing Ostriches* are the result of one woman playing with the possibilities embodied in the dressing up of another, much younger than she, as a bird. The pictures are Rego's meditations on the dreams and realities of women at a certain stage of their lives, superimposed upon and reinterpreted by, the body of the younger woman.

DANCING OSTRICHES FROM WALT
DISNEY'S 'FANTASIA' 1995 [65]
Pastel on paper mounted on
aluminium
Three panels, each 150 x 150 (59 x 59)
Saatchi Collection, London

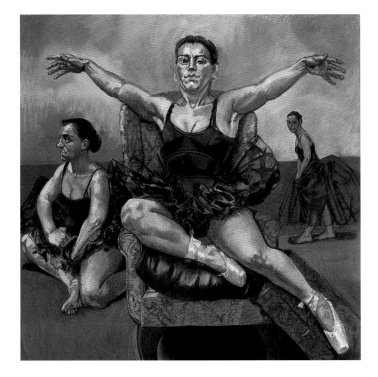

To supplement the *Dancing Ostriches* for *Spell-
bound*, Rego also attacked the Disney films *Snow
White and the Seven Dwarfs* (1938) and *Pinocchio*
(1940). Still half-embroiled in the trials and tribulations
of her ostriches, Rego concentrated in her *Snow White*
pictures on the relationship between the women in
the fairy tale – on the sexual rivalry between Snow
White and her stepmother.

Rego's re-telling of the story is a variant on the
story of Oedipus as enshrined in Sigmund Freud's
identification of the Oedipus complex as a significant
stage in the psycho-sexual development of an indi-
vidual. Oedipus, the mythological hero who killed his
father and married his mother, provided Freud with a
model for sexual jealousy within the family.
Interested primarily in men, Freud analysed a boy's
struggle towards sexual maturity as a battle between a
son and his father for the affection of the mother, the
primary female love object. In her *Snow White*
pictures, Rego investigates a female variant of Freud's
hypothesis, the series examining, as do many of her
earlier family narrative paintings, the struggle be-
tween the women of a family for the sexual attention
of the male. A chain of women striving for recognition
and attention from their father/husband links
together much of Rego's work. The ambiguity of *The
Family*, the bloodbath of *The Maids* and the tension of
the dog women are all focused around Oedipus, be he
physically incarnated within the picture or not.

We first encounter Snow White playing with her
father's trophies (fig.66), cradling a stag's head on her
lap in a pose riddled with sexual challenge. In this
picture she is supremely confident of her position in
the sexual struggle: Daddy's little girl at home in the
castle while her stepmother kneels, impotently tiny,
in the background. In *Snow White and her Stepmother*
(fig.67) there is some ambiguity as to the two

SNOW WHITE PLAYING WITH HER
FATHER'S TROPHIES 1995 [66]
Pastel on paper mounted on
aluminium
178 x 150 (70 1/8 x 59)
Saatchi Collection, London

SNOW WHITE WITH HER
STEPMOTHER 1995 [67]
Pastel on paper mounted on
aluminium
178 x 150 (70 1/8 x 59)
Whitworth Art Gallery, Manchester

SNOW WHITE SWALLOWS THE
POISONED APPLE 1995 [68]
Pastel on paper mounted on
aluminium
170 x 150 (66 7/8 x 59)
Saatchi Collection, London

women's relative supremacy. Is the stepmother,
dressed up to go out, inspecting Snow White's knick-
ers in some ritual humiliation reminiscent of school
games classes? Or is she acting as the girl's maid,
meekly helping her to undress? The latter seems
unlikely. We next see the stepmother in a position of
undisputed triumph as Snow White lies poisoned, a
fallen angel, still dressed in her Disney schoolgirl
outfit (fig.68). In her agony, she hovers between sex
and death, and finally emerges, triumphant, on the
prince's horse. She has beaten her stepmother, and
her desire for her father has been properly deflected
into her relationship with her future husband (fig.69).
Yet Rego's judicious use of a studio prop, an old fur
rug, to suggest the horse, adds a telltale note of ambi-
guity. What has Snow White done with her father?
Has she, like the girls on the rug in *Looking Back*, or
the original inspiration for *Dog Woman*, devoured
him in her struggle to come to terms with her own
burgeoning sexuality?

SNOW WHITE ON THE PRINCE'S
HORSE 1995 [69]
Pastel on paper mounted on
aluminium
160 x 120 (63 x 47 ¼)
Private Collection

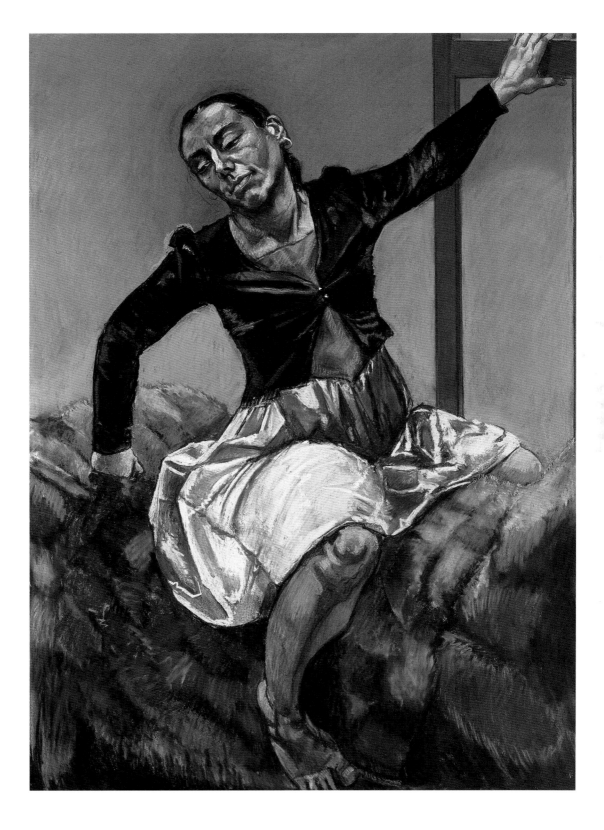

Paula Rego is best-known for her large-scale, narrative pictures in which multiple figures compete for the attention of the viewer and a key part in the story. However, throughout the history of her work there have been times at which single figures have emerged, often as iconic images around which a new series of paintings begins to form, or as the culmination of particular narrative cycles. These single figures collect together many of the artist's concerns at the time of their making, and are worth particular attention.

Untitled was made at a moment when Rego was between major cycles of painting. She had finished the dog women series (which itself was spawned by the first *Dog Woman*, a massively iconic single figure), and had not yet been asked by Philip Dodd to work with the Disney imagery that would give rise to the *Dancing Ostriches*. Rego describes the picture's genesis:

I had no subject. I had finished the dog women and I knew I didn't want to make any more, but I didn't know what to do next. I did something after a film I saw called Heavenly Creatures, *a film I loved about two girls who kill one of their mothers, but that didn't start anything, and I didn't know what else to do. Then I thought I'd like to do something with a girdle, and with a woman itching and uncomfortable in old-fashioned underwear (it's to do with mothers) and that's where she came from. She's real, I think, not like an illustration – she's the thing itself. Maybe because she does not come from a story, or have to carry a story. She's got a lot of story in her, but she's not an interpretation of anything, she just is. She's got lumps and bumps and she itches, like women do – like people do.*

She comes just before the Dancing Ostriches, *and in some ways she's similar to them – an ageing woman in an unflattering pose. But she doesn't have the spirituality that they do, the longing and the aspiration to loving. They have a social role, or at least they think they do, whereas she's outside all that. They're showing off, wanting to be looked at, whereas she wasn't made to be looked at. I rarely think of anyone looking at my subjects except myself, although some of them, like the ostriches, go out of their way to court attention. This woman, I think I thought of her as cast out, a sinner in the wilderness, and maybe she's an early attempt to work with the imagery of Mary Magdalene. A real, lumpy, bumpy woman who has sinned – it's an aspect of the human condition that has always appealed to me.*

Untitled is made, as are all Rego's major works after around 1994, in pastel. Rego has spoken about what it was that drew her to the medium:

I had always known about pastel, and knew I liked using it, but I hadn't really thought of using it to make big pictures until I started experimenting with it on a large scale. I worked on paper laid on canvas, already stretched onto aluminium to make a rigid surface which could be supported by an easel. I made some things, then I found myself buying more and more colours and working in pastel more and more until it became the medium that I am most at home with. I think it was the ease with which you could change things that initially attracted me to it – you can just go over and over something until it's right. Also, there was the fact that it looked real, or naturalistic – solid. With pastel, it's like drawing and painting at the same time. Painting in oil or acrylic, you draw a line, and then you fill it in. It seemed like I was forever filling things in, filling up gaps to make things look solid. With pastel, it starts off solid – everything is drawn, one line after the other, all the lines going in and out of each other, building something up in line which is colour at the same time. I found that the process really suited me.

This one took me a long time. I worked and worked on her with Lila, my model, and then I had to put her aside and do something else – a small version. Then I started again, and redrew everything, so that in the end she was not composed at all – that's why her legs are so short! I had to ask Lila to stand with her legs turned inwards so that they were as short as possible, but they still aren't really long enough for her body. This gives her an awkwardness that I like, however. She has something of the grotesque about her, and the awkwardness of the drawing mirrors the awkwardness she's feeling. She's awkward, and she's a little grotesque, but it's not an erotic grotesque – I think that there's nothing erotic about her at all.

Vic said that you should never try to get things right. It was one of his biggest put downs when looking at the work of other artists – 'He's trying to get it right.' He thought you should never show the effort. When he worked, he would stare at the canvas for ages, seeing the picture into being, then paint it once, just right. Sometimes he would change the colours, but that's all. But I'm not like that. I draw the thing into existence – I can only think through doing.

UNTITLED 1995 [70]
Pastel on paper mounted on
aluminium
160 x 120 (63 x 47 ¼)
Private Collection, Portugal

AMBASSADOR OF JESUS 1998 [71]
Pastel on paper mounted
on aluminium
100 x 80 (39 3/8 x 31 1/2)
Saatchi Collection, London

LOOKING OUT 1997 [72]
Pastel on paper mounted
on aluminium
180 x 130 (70 7/8 x 51 1/8)
Private Collection

FATHER AMARO

In 1998 Rego was invited to make a solo exhibition of new work at the Dulwich Picture Gallery, renowned for its collection of Old Master paintings. Rego was particularly attracted to the gallery's works by the seventeenth-century Spanish painter Bartolomé Esteban Murillo, who has long been a favourite of hers. She, and the staff of the gallery, were intrigued to see how her work might look alongside his.

Her starting point for the exhibition was a novel written by the Portuguese writer Eça de Queirós in 1876, called *The Sin of Father Amaro*. Banned until fairly recently, and only translated into English in 1994, the novel had been a particular favourite of Rego's non-conformist father. A tale of small-town claustrophobia, the corruption of the priesthood and society's polite yet devastating persecution of women, the novel is like a Portuguese *Madame Bovary*. Its hero, Amaro, is a young man without a vocation who is forced into the priesthood for want of any alternative career prospects. He is sent to the small town of Leiria, where he lodges with a woman and her daughter, whose affection he soon wins. They embark on a clandestine affair, even though she is engaged to someone else, and she becomes pregnant. Failing to resurrect her former relationship in time to pass the child off as her fiancé's, Amelia is spirited away to have the child in secret. Both she and the child perish in childbirth, and the novel ends with Amaro as he was at the beginning – alone and unworthy, but completely unscathed.

For Dulwich, Rego set out to make use of this material, judging that the time and the context were right for her to return, pictorially, to Portugal. As ever, she sought not exactly to illustrate the novel, but rather to make paintings which might occupy similar ground, share atmosphere and meaning. She fixed on certain points of focus within the story around which she could spin plausible and equivalent visual narratives, moments of connection with the novel which would make complete pictorial situations. Eça de Queirós's interest in social crimes and in the strengths and vulnerabilities of the family unit within society matches Rego's own, and provided her with a new direction in which to pursue her researches into the public and private relationships between men and women.

Rego first turned her attention to Amaro himself, fascinated by the idea that the course of a man's life could be determined by the power of a vocation to which he felt no commitment. Men are seldom the main subject of the artist's work, but her interest in working with the Father Amaro material coincided with a new friendship with a man who would sit for her, and with whose collaboration the story developed. Rego's Amaro is confused and pathetic, selfish, sly and cunning. Though sometimes tormented, he is never heroic and is always culpable, and Rego systematically undermines any pretensions he may have to misunderstood nobility. The artist depicts him alone and in social groups, returning to the more complex narrative pictures she had temporarily abandoned with the dog women and their successors. Thus we see him first in *The Company of Women* (fig.80, pp.98–9), a picture in which Rego imagines the damage that the attention lavished on Amaro as a child may have done to him in later life. She shows him, as an adult, in the situation of a young child dressing up in women's clothes, nestling into the skirts of a woman sewing. He too is an ostrich, an adult who carries around with him the results of his failed childhood dreams. The picture is a study of a man's refusal to accept responsibility for his own life, a man who seeks only the re-creation of the uncomplicated ease of his childhood. As regularly happens in

PERCH 1997 [73]
Pastel on paper mounted
on aluminium
120 x 100 (47 ¹/₄ x 39 ³/₈)
Private Collection

Rego's narrative work, and particularly in this cycle of pictures, the artist collapses conventional time within the picture, offering the viewer an insight into several stages of the story at once. The two women sewing are both a reference to Amaro's childhood and a representation of Amelia and her mother, in whose house the adult priest attempts to recapture the comforts of his childhood. The mirror, its reflection not quite what it should be, signals the scenario's atmosphere of concealment, intrigue and mistrust.

The theme of dressing up in *The Company of Women* echoes that present throughout the book. At one point Amaro dresses Amelia as the Virgin Mary in a neat re-sexualisation of the priest's vow of marital fidelity to the church as symbolised by the virgin. A trope of hypocrisy, the idea that a man's identity is vested more in his clothes than his deeds enables Rego to emphasise Amaro's complete lack of integrity. We see him dressed as a priest, as a woman and as a penitent hermit, yet we trust none of these incarnations. We cannot believe in his torment: even in *Perch* (fig.73), which shows him supposedly wrestling with his conscience alone in his study, Rego allows him none of the sanctity of the St Jerome whose iconographical history she quotes. Amaro hovers in mid-air, as insecure and unsubstantial of pose as he is of character.

We first meet Amelia in *Looking Out* (fig.72), a picture of entrapment and frustration. A timeless image of a woman unable to determine the course of her own life, it shows Amelia waiting for deliverance, seeking a solution in the form of a man who can carry her away. This is Amelia at several points in the story; in fact it is Amelia's constant condition. It may be that she is in the first flush of her affair with Amaro, looking for his pseudo-intellectualism to rescue her from the confines of bourgeois life with her mother. Or we may

be later on in the story, and it is perhaps her former fiancé for whom she looks, desperate for him to renew his promise of marriage so that she may escape the fate of shame and death that awaits her.

The Coop (fig.74) similarly represents the claustrophobic inevitability of Amelia's situation. The authorial voice of the novel never enters the room in which Amelia lives out her confinement, delivery and death. Rego has no such squeamishness, and imagines a world of waiting which is exclusively a world of women. The picture is a compendium of pregnancy, from dreaming to desperation. In the centre sits a pregnant woman, a small doll upon her lap symbolising the impending birth. Beside her another, non-pregnant woman, or perhaps an earlier incarnation of the same one, sits and dreams. In the background, a third woman, older than the first, helps a young girl either into or out of bed. There is something about their situation that suggests female complicity – an abortion perhaps, given the faint air of menace which hangs about the picture. The dangling cockerel and malevolent pigeon seem to speak of some bizarre ritual, the too-small doll right at the centre of the picture an indication that all will not end well.

As indeed it does not for Amelia, although in Rego's account of her story she emerges, if not exactly triumphant, at least alone and intact. *Angel* (fig.76) is one of the last pictures in the series, a sombre-toned pastel with overt echoes of Murillo. Both guardian and avenging angel, she confronts the viewer (and the reader and writer of the novel) with a sword in one hand and a sponge in the other. She wields the instruments of Christ's passion with uncompromising conviction, challenging all comers to thwart her undisclosed purpose.

It seems typical of Rego that she cannot abandon the heroine of her narrative, as de Queirós does his, to

THE COOP 1998 [74]
Pastel on paper mounted
on aluminium
150 x 150 (59 x 59)
Private Collection

DIONYSIA 1998 [75]
Pastel on paper mounted
on aluminium
100 x 80 (39 3/8 x 31 1/2)
Private Collection

ANGEL 1998 [76]
Pastel on paper mounted
on aluminium
180 x 130 (70 7/8 x 51 1/8)
Collection of the artist

UNTITLED NO 3 1998 [77]
Pastel on paper mounted
on aluminium
110 x 100 (43 1/4 x 39 3/8)
Private Collection

UNTITLED NO 7 1999 [78]
Pastel on paper mounted
on aluminium
110 x 100 (43 1/4 x 39 3/8)
Private Collection

a disgraceful death. In Rego's re-created world of Portuguese petty-bourgeois intrigue, it is Amaro who fades away, while Amelia remains to cope alone. The ability of women to cope, and specifically to cope with the often unwanted consequences of their own sexuality, is the real subject of Rego's Amaro pictures. It defines and directs her Amelia, and is the reason for the introduction of Dionysia, the aptly-named go-between who keeps Amelia's secret and arranges to deal with the fruits of her pleasures (fig.75). Dionysia, midwife and abortionist, arranges Amelia's confinement.

In 1998, immediately after completing the Amaro pictures for Dulwich, with her mind still on the repression that in the past characterised female sexuality, Rego received news from Portugal that reminded her that much of this repression still lingers in contemporary Portuguese society. Abortion remains illegal in Portugal, available only in exceptional circumstances. A referendum was held to try and change the laws, but an insufficient proportion of the population turned out to vote, so the situation remained the same. Infuriated by what she saw as people's deliberate refusal to face up to the issue, and their willingness to accept and maintain the status quo as reflected in de Queirós's novel, Rego was roused to engage with politics in her work in a way that she had not done since her earliest paintings and collages on the subject of Salazar.

Rego made a series of drawings, pastels and prints, all of which have abortion as their subject. Not the legal, hospital-sanctioned abortion still unavailable to Portuguese women, but back-street operations arranged by and for women, situations emblematic of the often desperate measures women and girls may take to rid themselves of the consequences of their – and someone else's – actions. Intended for exhibition in Portugal (where it was shown to great critical

acclaim and much media attention), the series, called simply *Untitled*, depicts a variety of women, from schoolgirl to society lady, either preparing for an abortion or coping with its aftermath. Like the *Dancing Ostriches*, these women contort themselves on and around the furniture of the artist's studio, with no elaborate narrative scenario to detract from the business in hand. Like her dog women, they confront their own sexuality on their own.

The abortion pictures are images of revenge against social injustice, of the triumph of will over circumstance (figs.77–9). In seedy situations, on sagging sofas, over hideously prosaic plastic buckets, the women take up a sequence of poses from the practical to the timeless. One waits, her feet braced on a pair of folding chairs as if in antenatal stirrups; another plummets into the picture, a fallen angel in the manner of Snow White. Some cower and cringe, others squat and stare the viewer out. The details – a discarded watch and pants, comforting woolly socks pulled on with a smart dress, a school uniform worn with the confident insouciance of the rebel – are heartbreaking, but the artist makes it clear that what is happening is the intention of each woman, who fully accepts her role as protagonist in the action. Crucially, they are doing this, they are not having it done to them: it is their right and their choice. Many of the women meet the viewer's gaze. Others are turned in on themselves, making it clear that what is happening is no one's business but their own. None of them accepts the role of victim.

TRIPTYCH 1998 [79]
Pastel on paper mounted
on aluminium
Three panels, each
110 x 100 (43 1/4 x 39 3/8)
Marlborough Fine Art, London

This is one of a series of pictures made in response to an invitation to show at the Dulwich Picture Gallery. Its subject is taken from the Portuguese novel, *The Sin of Father Amaro*, by Eca de Queirós. On one level an illustration of an event in the novel, it is also part of Rego's ongoing study of human nature, acceptability and unacceptability, although this was the first time she had used a man as the principal protagonist. The artist has explained:

This picture was made for Dulwich, although it was not really about that. I was aware that it was going to be in dialogue with the paintings in their collection, but I couldn't worry too much about that – my work tends to make its own visual and narrative worlds and, in any case, it wasn't always going to be seen in Dulwich. I wanted to make something Portuguese, and something that had to do with my father. I chose to use the book because he had been interested in it while it was still banned in Portugal – as it attacked the priesthood, it was very controversial.

This is the first picture in the series that dealt with the book. It uses narrative material taken directly from it. When Amaro, the main character, was little, he was orphaned and sent to live with his godmother, who had no time for him. The only people who were kind to him were the servants, who used to dress him up as a girl and play with him. He was a very sensitive and unhappy child, and this was his only comfort. Dressed as a girl, he felt important, knew himself to be the centre of attention.

My interest in using this material coincided with Tony Rudolf agreeing to sit for me, and several of the pictures have a sense of working out ways to use a new model. He is wonderful to draw – he's very angular, with long feet and forearms. I can get him quickly, and I can draw him over and over again, like I can Lila. But he doesn't change like she does, because I can't identify with him as I can with her, can't play the same games. Having him as a model, however, has made me interested in using men in pictures for the first time, in exploring how that might work.

Here, I've drawn him as an adult. I didn't want exactly to illustrate the episode in the novel, but rather to look at the reality of a person, where they come from. To do him aged nine, dressed as a girl, would have been meaningless; it would have had no impact whatsoever. The point is, that as a man grows up, he still has the same kind of needs and hang-ups as when he was small; he still appreciates the same kind of attention. In fact, perhaps it is because he got that kind of attention that he has become hung up about it – it is more real to him as an adult than it was when he was a child; it has conditioned the kind of adult he is. It isn't a memory picture; it isn't him remembering what it was like to be a child. Perhaps it's a fantasy picture, and he's imagining what it would be like now to be dressed as a woman, snug and well-loved, wedged between two archetypal women – the sexy one and the motherly one sewing. He is Amaro, the priest in the book, but the women aren't really characters, they're just there to explain him, to be used by him.

THE COMPANY OF WOMEN 1997 [80]
Pastel on paper mounted on aluminium
170 x 130 (66 7/8 x 51 1/8)
Collection of the artist

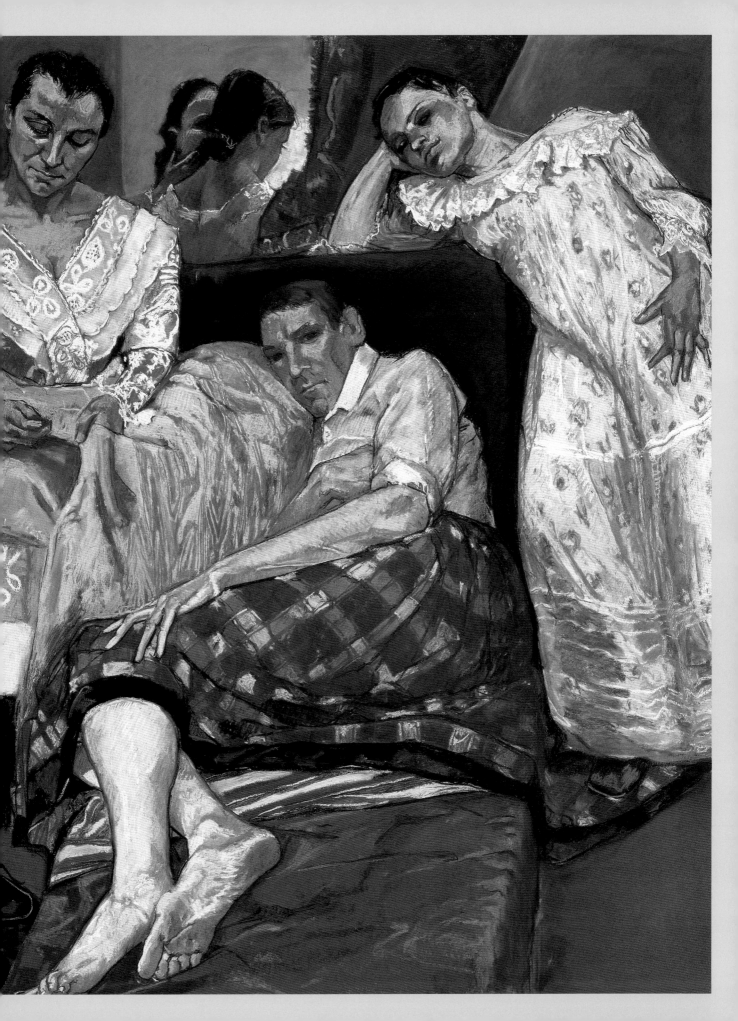

William Hogarth
MARRIAGE À LA MODE: 1. THE
MARRIAGE SETTLEMENT c.1743 [81]
Oil on canvas
90.8 x 69.9 (35 3/4 x 27 1/2)
The National Gallery, London

8

The strength of women, and their expedient practical-ity in the face of intransigent social situations is the subject of Rego's two most recent cycles of work, both also made in response to exhibition invitations.

The first, *Encounters: New Art from Old*, gave Rego the opportunity to return to the National Gallery. In celebration of the year 2000, the gallery, in the words of the preface to its catalogue, 'invited twenty-four great artists of our time to converse with the greatest artists of all time', hoping to uncover the continuing relevance of the National Gallery's collection to contemporary art and artists. Each artist was asked to choose a particular painting with which to work. Rego, thinking this might be the moment to bring together her long-standing interest in satirical painting and her more recent researches into the possibilities of the grotesque, chose William Hogarth's *Marriage à la mode c.*1743.

Six paintings rather than one, Hogarth's narrative cycle tells a cautionary tale that uses the conventions of arranged marriage as a metaphor for the ills of eight-eenth-century high society in London. Themselves part of a series of what Hogarth called 'modern moral subjects', the paintings were later copied as etchings. Hogarth hoped that in this way their message may be more widely received and understood (Rego's abortion etchings were made in a similar spirit). Hogarth's paintings tell the story of an arranged marriage between the son of an impoverished nobleman and the daughter of a rich, common-born alderman. Sold into marriage to satisfy their fathers' need for money on one hand and social respectability on the other, the young people lead dissolute lives, ending in the murder of the young man (now the Earl) by the lover of the young woman (now the Countess), and the suicide of the Countess, the only record of the disastrous marriage being the syphilitic child they leave behind.

The story's tragic end is prefigured in its beginning, and Hogarth paints the entire tale into the first picture in the cycle, which shows the negotiation of the marriage contract. The delightfully-named Earl of Squander points to his family tree, resting his gouty foot while the Alderman plies him with gold coins. The young people ignore each other, the dandified young Earl taking snuff while his future Countess is encouraged by the whisperings of the lawyer Silvertongue, who will soon become her lover. The paintings on the wall of the elaborately decorated room speak of the trauma to come: a Medusa shrieks in horror while all around her young saints submit to their martyrdom.

Rego came to Hogarth already steeped in the stulti-fying domestic politics of de Queirós's *The Sin of Father Amaro* and immersed in the inequality of women's position in society as expressed in her abor-tion pictures. Familiar with the iniquity of arranged marriage from her upbringing in 1940s Portugal, she decided to transpose Hogarth's action to her native country, bringing his cautionary tale up to date in a contemporary exploration of the manoeuvrings and strategising at work in family life, of cultural attitudes to women in society, and of the struggle between the sexes for social, political and environmental control.

Rego counters Hogarth's 'modern moral subject' with what she terms a 'modern love story'. Her approach shares several similarities with his: she also uses the example of one particular young couple as a metaphor for human nature and relationships. She too makes the first picture of her cycle portentous, using both her own predilection for condensing different narrative times into one painting and Hogarth's device of pictures within pictures to jump backwards and forwards in symbolic and real time. Rego also finds echoes of her own interest in the power of the estab-

lished tropes of Christian iconography in Hogarth, detecting an echo of the figure of Christ in scenes depicting his descent from the cross in Hogarth's murdered Earl. Structuring her 'conversation' with Hogarth as a triptych, Rego develops his use of Christian iconography to underpin her contemporary narrative.

Updating the traditional functioning of a triptych, Rego concentrates the action of her story in the two outer panels, leaving the centre to act as a pivot or hinge, around which the whole painting turns (fig.82). The left-hand panel, *Betrothal*, is the busiest, and is also the most faithful to Hogarth. It shows both the transaction which sets off the subsequent, tragic chain of events, and the inevitability of that chain reaction. This time, the business is done by the women. A smart, upper-middle-class woman perches uncomfortably on the arm of a chair, looking down on her *nouveau-riche* former maid who shelters her nervous-looking son behind her. The fact that the two women are engaged in some kind of – possibly unspoken – negotiation is made evident in their interlocking knees and legs. Their reluctance to be thus conjoined is hinted at in the clashing yellows of their skirts, and the gulf between their upper bodies, a classic instance of body language withdrawal, into the space of which Rego inserts an altogether more disturbing conjunction of girl and dog. The picture plays with the grotesque – feet, hands and heads are distorted, expressions exaggerated, the pastel very deliberately applied. No one looks at any one else, and a series of sidelong glances serves to throw the whole picture off balance.

As a self-confessed love story, *Betrothal* offers a variety of affections, none of them particularly healthy or happy. The little girl in the white dress, seemingly still innocent of the ways of the world, fondles her dog

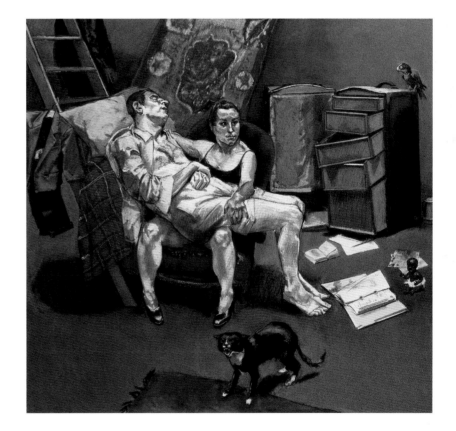

THE WEDDING GUEST
1999–2000 [83]
Pastel on paper mounted
on aluminium
150 x 150 (59 x 59)
Collection of Elaine and
Melvyn Merians

(misplaced symbol of marital fidelity) suggestively with her feet. She could be flirting with the viewer, but as we look more closely at the picture we realise that the gaze she is in fact returning is that of her father, who surveys the sale of his daughter from the safety of the mirror. The love the young boy shows for his mother, cowering, Amaro-like, in the safety of her shadow, seems similarly unhealthy. The worst kind of love on show is, however, reserved for a picture-within-a-picture, which this time is not a painting in its own right, connecting only symbolically with the main action, but is rather a flash-forward, a portent of the power-play to come.

The right-hand panel of the triptych, *Shipwreck*, jumps forwards thirty years to the aftermath of the marriage we have just seen negotiated. Using the classic metaphor of life, particularly married life, as a journey, Rego sails her characters into stormy seas and ship-wreck. The man lies in the woman's arms, seemingly ill, possibly dead, definitely bankrupt. He has been to Brazil, like many Portuguese men, to seek his fortune, but has lost it all. His trunk is empty, and he has only a parrot and a black doll (alluding, so the artist would have it, to a second family in South America) to show for his efforts. His wife, on the same chair and in a similar pose to when we first meet her as a little girl in *Betrothal*, cradles her husband in her lap. Her steadfast gaze is the only certainty in the picture, as composi-tionally it shifts and slides, the trunk toppling, the chair on which the couple sits threatening to pitch them forward out of the picture plane.

The central element of Rego's triptych, *Lessons*, is its most timeless, and in several ways it offers a counterpoint to the rape scene secreted within *Betrothal*. A mother, a model of mature sensuality and self-esteem, wearing her hairdryer like a helmet, both protective shield and weapon of choice in the battle of

the sexes, teaches her young daughter the ways of the world. The daughter looks up to her as, Rego has remarked, a saint may look up at Jesus, respecting her experience, keen to profit from the literal and metaphorical baggage she carries in her capacious handbag.

The rape scene tells a less positive, but nonetheless instructive story. A man, fully clothed, stands impas-sively by while a girl struggles either into or out of her clothes. Rego sees this as a similarly formative moment in the experience of the young girl, condi-tioning the kind of woman she will become. In a closely-related picture she pushes the visual clumsi-ness of the grotesque perilously close to caricature to explore the effect that such an event may have on a woman, and introduces the viewer to *The Wedding Guest* (fig.83), a bystander in her modern love story, but one who provides a powerful commentary on the action. A mature woman, the guest stands uncom-fortably half in and half out of her smart wedding outfit, teetering on her high heels, balanced against a wash-basin. The awkwardness of her pose and painterly treatment match the precariousness of her situation, and possibly the blurring of her vision – we imagine first that she is drunk, caught short, unable to stop herself from peeing in the basin at a smart party. Then again, why should she unbutton her blouse? Perhaps her proximity to the sink is in fact more to do with a desperate attempt to regain her decency and her dignity, and what we are seeing is a reprise or indeed the long-delayed aftermath of the rape scene of *Betrothal*.

The moral of Rego's 'modern love story' is that people, particularly women, must learn to make the best of their lot in life, must adjust to if not accept the reality of their situation, then be confident in their ability to cope with whatever it brings them. A similar

CELESTINA'S HOUSE 2000–1 [84]
Pastel on paper mounted
on aluminium
200 x 240 (78 $\frac{3}{4}$ x 94 $\frac{1}{2}$)
Saatchi Collection, London

THE WIDE SARGASSO SEA 2000 [85]
Pastel on paper mounted on
aluminium
180 x 244 (70 7/8 x 96 1/8)
Marlborough Fine Art, London

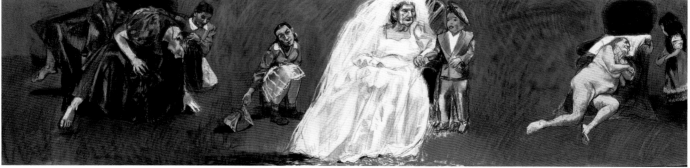

theme runs through the artist's most recent work, made in response to an invitation to show at Abbot Hall Art Gallery, Kendal and the Yale Center for British Art, New Haven in 2001 and 2002. Called *Celestina's House*, the Kendal exhibition focused on the figure of Celestina, a traditional character from Spanish and Portuguese literature. Rego describes Celestina as a procuress and go-between, a middle-aged woman who was once a courtesan, and who in retirement performs services for women. In Portugal, her story belongs to the more ribald school of writing so beloved by Rego – she is a character whose sardonic, practical humour belongs to the carnivalesque.

For Yale, Rego added the story of *Jane Eyre* to that of Celestina's House (see fig.95, pp.122–3). In a series of etchings and one pastel triptych she contrasts Jane, the heroine of Charlotte Brontë's novel, with Bertha, *Jane Eyre*'s mad woman in the attic and the central character of Jean Rhys's *Wide Sargasso Sea*. Seeing in Jane a passion equal to the more accessible enthusiasms of Bertha, Rego understood both women's story as a struggle for control, first of the self, then of the situation.

The Wide Sargasso Sea 2000 (fig.85) was made during the development of Rego's ideas around Celestina, ideas which had a long and complex genesis. More of a drawing than a painting in pastel, *The Wide Sargasso Sea* was made in an improvisatory, exploratory manner, the artist using the enormous sheet of paper as if, she says, it were a series of small pieces, making the composition up out of individual life drawings completed as the opportunity arose and then loosely bound together into a story by the title. The result is a scene seemingly conjured in the imagination of the old woman in the yellow dress and veil at the right centre of the drawing. Perhaps it is her family collected around her, or perhaps the figures are

memories, which have become jumbled and out of synch, especially in the predella panel that accompanies the work. This shows four ages of woman – school girl, young woman, bride, old woman – yet the bride has, Miss Haversham-like, grown old in her wedding finery. The title speaks of frustration and sequestered madness, of betrayals and claustrophobia.

The naked old woman of *The Wide Sargasso Sea*'s predella panel provided Rego with a route into the story of Celestina. The nude is almost unprecedented in the artist's work: she normally eschews this male-dominated, traditional mode of female representation. In this case, however, she wanted to accentuate through nudity the vulnerability of the dreaming old woman, and hired a professional model, whom she makes crawl out of the space of the drawing. She is headed for *Celestina's House* (fig.84), where, rejuvenated and bare-breasted, she sits triumphant. This is a Celestina at the height of her powers, in control of her own destiny and that of her strange household, made up of figures grouped in twos and threes around her. As with the preceding drawing, the status of all these figures is unclear, since the picture plane collapses narrative time. Some of them seem most plausibly to be visions of the heroine at later and earlier points in her life.

A complex narrative, like the ironic and self-conscious contrivance of operetta, structures our experience of the picture. The women dominate, with the few men either servile, precarious, hen-pecked or asleep. From the face of Celestina at the table, the picture moves out in a spiralling circle, taking in the young woman in the foreground contemplating her sleeping man; the two women either cooking or working some kind of feminine magic in the grotto in the background; and the little girl, her innocence re-preserved by the intervention of her grandmother

CONVULSION 2000 [86]
Pastel on paper mounted
on aluminium
180 x 150 (70 7/8 x 59)
Private Collection

(both are Celestinas, one idealistic, the other prag-
matic). The circle widens to include the two women
sewing, then the young man perched on the stepladder
and, finally and crucially, the young woman tumbling
into the picture and the tiny old woman staring at her
as she comes, begging to be taken out of it.

Rego speaks of the entire picture 'being lassoed' by
these two women, one falling, the other in supplica-
tion. They round off the pictorial rhythms, bringing
both the composition and the story to a close.
Celestina, at the table, contemplates her youth and her
old age. And, practical though she is, what is to come
clearly terrifies her.

Much of the work Rego has done around Celestina
focuses on the often traumatic nature of the relation-
ship between women and their ageing mothers. In
her vision, the relationship begins with the physical,
and moves towards an acknowledgement of its
impact on identity. Rego's mothers and daughters
retain their bodily connection to each other, and it is
through this that their awareness that one will
become the other is mediated.

In *Convulsion* 2000 (fig.86), a woman, watched by
a maid and a little girl, recoils from her mother, who
lies prostrate and in need on the floor at her feet. The
maid and the girl are removed from the action, hover-
ing in liminal space, one in a doorway, the other in a
mirror. Although at least four other women, as the
artist puts it, 'came and went' during the construction
of the picture, in the finished version the drama
unfolds between the woman and her mother alone.
The younger (but already middle-aged) woman, her
status as daughter confirmed and accentuated by the
huge chair on which she squirms, attempts to reject
and deny her connection to the old woman on the
floor. Her expression is one of almost visceral disgust
– she sees herself there as well as her mother, and the
picture may as well be called *Revulsion*. Yet the old
woman, in extremis, will not give up her rights to
physical and emotional connection to her daughter.
She grasps the leg of her chair, and fights to return her
gaze. Like the tiny old woman in *Celestina's House*,
she is vulnerable but somehow deadly. She reaches
out to her daughter, not because she wants to stay
where her daughter is, but because she wants to take
her with her where she is going. And, knowing what
we know about the persistence of Rego's women, we
suspect that she will succeed.

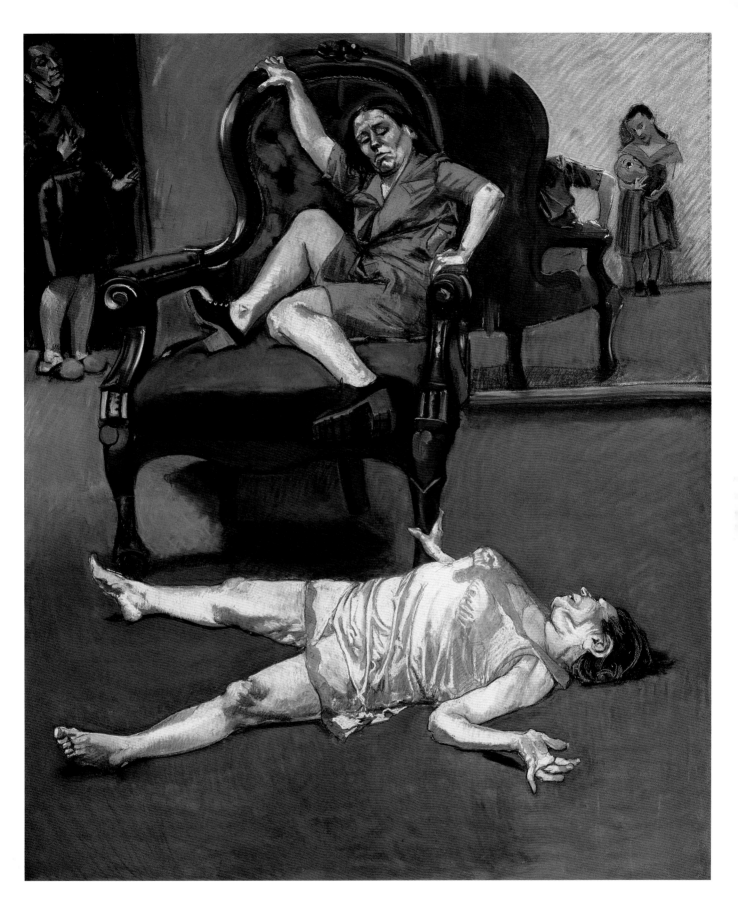

This triptych shows Martha and Mary Magdalene flanking the Virgin Mary in the classic pose of the pietà, mourning her dead son. Martha and Mary Magdalene were sisters both to each other and to the dead and resurrected Lazarus. Martha, Rego's painter, is the Bible's practical one. When Jesus goes to open Lazarus's tomb, to show him raised from the dead, Martha worries that the body will already have started to decompose. When, flush with the success of the miracle, Jesus comes to the family home, Martha prepares and serves the food, while her sister Mary simply sits rapt at the master's feet. Martha receives no thanks, as Jesus prefers the attention of her sister, who goes on to become Magdalene, a woman of dubious moral reputation who nevertheless is the chief witness to Jesus's own death and resurrection.

Rego made the triptych while she was working on the Hogarth pictures for the National Gallery's exhibition *Encounters*. She saw it as something of an insurance policy, something to show if the Hogarths failed to work out. She began with the pietà in the centre.

PAULA REGO I'd just got back from Spain, where I saw this amazing sculpture of Mary holding the dead Jesus and looking really cross, and I wanted to try and do something with it. It was painful to do – I posed the models and then we went on and on and I couldn't get it right. I changed the background, I changed the colours, I changed him, I changed her, it was a nightmare.

FIONA BRADLEY What made you persevere?

PR It was the expression on the face of the sculpture that I thought would be the key to the picture – Mary looking really cross and disgusted. I wanted to get that.

FB Did you deliberately use the props from the studio to make her look more like a real person and less like the Virgin Mary?

PR I tried leaving them out at first. I put them in the drawing, and then I removed them in the painting, so that the two figures would look more like the figures in the sculpture. But it looked ridiculous – they were just hanging there. So I left them in. They do help the story, but that's because they help the models. I always leave in what I've used to make the poses work. If you take it away it's like disposing of the evidence somehow.

FB Knowing that you're likely to leave the props in, do you choose them carefully?

PR No, it's whatever is around that will work.

FB Are you interested in the fact that certain things can be recognised from one picture to the next, and may begin to accrue meaning: like that cushion, for instance, which is also in the dog woman picture *Sit*?

PR No. I don't think of it really. I don't see a connection, because for me they're different every time I use them. The cushion doesn't mean anything on its own, it's just holding him up. It's left over, transformable. If other people recognise it and want to make something of it, then that's fine too – the pictures are open; the meanings have to be able to move about.

FB Was this always intended to be a triptych?

PR No, I just did her and him on their own. Then I did the Magdalene to go with them.

FB How does she relate to the other Magdalenes that you've done?

PR Well, she's not in disguise; she owns up to being a Magdalene. Like the others, she's outside, she's got her coat on, waiting for a train or something. But she's OK – she's over it all; she's a teacher now.

FB She seems to be wearing some kind of uniform?

PR Yes. I wanted her to wear the uniform of the Portuguese Fascist Youth. When I was a child, I wasn't allowed to go to the classes they ran, though I did sometimes, and all they taught us about was the devil – I get all my ideas about the devil from them. The uniform represents something forbidden, unacceptable, and I thought it might give her an air of transgression.

FB Whereas Martha …

PR Has nothing transgressive about her at all. She's the practical one, finishing it all off, putting it all in a painting – all the disgust, the hope and the eventual survival. The rhythm of the triptych starts with her and comes back to her. She contains it all, and together with her sister she buttresses all the strong emotion and the difficulty in the centre.

FB Do you think that the central panel needs the two outside ones? Is it inevitably a triptych?

PR It is now, and it's better for being one, I think. But it also looks good on its own. I like thinking about how pictures will work together on a wall as I'm making them. It's only recently that I've started to do this, since we made the exhibition in Liverpool. I knew I wanted the ostriches to hang together in a particular order, in a kind of chapel. But I hadn't thought like that about the dog women at all – they were just a series of single pictures. But when I started to hang them with you, they changed, forming new relationships with each other. Now I try to put that into my work from the beginning, to think about ways to control how they'll work together. I see how the characters work in the space of a room, as well as in the space of the picture. I didn't think about that when I did the National Gallery mural – I just made three large pictures, quite self-contained. I'd probably do it differently now.

MARTHA, MARY, MAGDALENE 1998 [87]
Pastel on paper mounted on aluminium
Each panel 110 x 100 (43 ¼ x 39 ⅜)
Private Collection

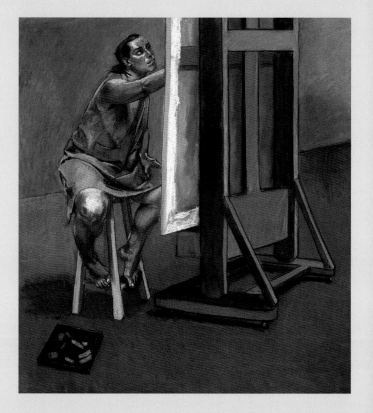

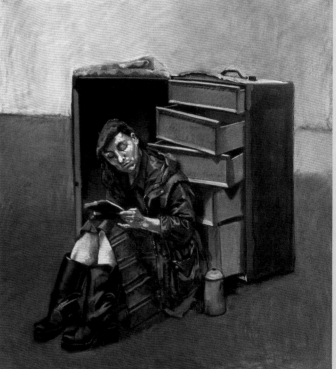

Much of Paula Rego's work begins by accepting the conventionally unacceptable. From her early visceral paintings to her most recent narrative pastels, she has throughout her career been concerned with bringing to light those parts of life and the relationships through which it is structured that tend more usually to be brushed under the carpet. Interested in the everyday, but supremely uninterested in conforming to what might be expected either of her or her characters within that everyday, the artist confronts and creates situations in which the often embarrassing, unassimilable facts of life are brought unashamedly to the fore.

Rego's primary subject matter is the stuff of ordinary life – the events and emotions of human beings as social animals. Yet she is drawn to the antisocial within the social, the often undesirable complexities that make us what we are but which can never be quite admitted in polite society. A concern for the antisocial emerges in Rego's work in the subject matter she chooses to address, the stories to which she is drawn, and the manner in which she presents them. Her earliest work is concerned overwhelmingly with sex; with the exploration and presentation of a kind of sex that revels in its own physicality and messiness, a sex that is linked to an overwhelming greed and an all-consuming desire. *Gluttony*, of 1959 (fig.88), is a prime example. It was made during a time in the artist's work when, in her own words, 'everything was pregnant, full of tits and bums and so on. It looked almost edible – paint squashed directly from the tube; smeared with the hands.' An instance of a painting's making echoing its meaning, *Gluttony* is redolent of the greedy process of its construction. A picture of excess, of ingestion and expulsion, it is also known as *The Eating*, this more active version of the title, verb rather than noun, making the picture's visual energy more explicit.

Gluttony is a painting made about, of and with the body. Its reds and pinks, its lush paint and its rounded, gaping forms speak of unrestrained, untidy human and animal flesh. Not quite abstract, its forms are nevertheless semi-submerged within a conglomeration of breasts, bottoms and the vast, gaping mouth which seems either to be devouring or regurgitating the whole picture. It is messy and unresolved, and is about messiness and lack of resolution; about a physical world in which bodies refuse to remain intact, but are instead permeable, both vulnerable and voracious in relation to the world around them.

The painting is marked by a sense of impending and actual disintegration, as the forms within it merge both with each other and with their surroundings. In much of Rego's early work, composition and decomposition go hand in hand in a way that seems most clearly understandable in the light of a concern to show the appetites and ambivalences that inform real relationships, but which polite society often pretends are not really there. *Birth* 1959 (fig.89), in particular, brings its forms into being with a violence that threatens to overwhelm them. Again viscerally sticky, with pink and red paint smeared directly from the tube, the picture shows an enormous bottom, almost completely engulfing a tiny child, drawn schematically at the dead centre of the painting. The maternal body is all paint, disgustingly and pleasurably squashed onto the canvas; it is pure physicality. The child, on the other hand, is all concept, a sign or a cipher of a child, clearly demarcated yet equally clearly threatened with re-absorption by the maternal body. This is not a painting of an idealised, privileged mother-love, but rather of the link between childbirth and sex, pain and a reassessment of identity.

GLUTTONY 1959 [88]
Oil on canvas
100 x 140 (39 3/8 x 55 1/8)
Private Collection

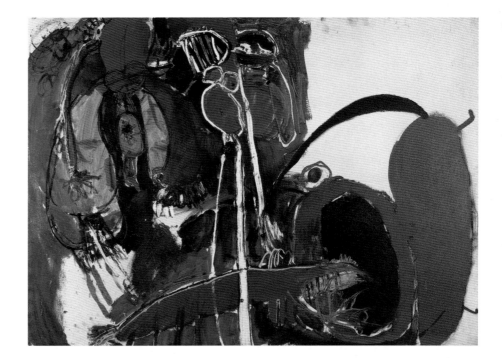

Birth and *Gluttony* are both characterised by a kind of horrified fascination, a pleasure in the uncontrolled and visceral which seems to be a mark of the presence of the antisocial in Rego's early work. It is a fundamental part of the pictures to do with sex, and it is also clearly linked to violence, which, while never far away in the sexual pictures, comes more clearly to the fore when the artist turns her attention to politics. *Salazar Vomiting the Homeland* 1960 (fig.90) is full of unrepressed violence, the disgust the artist feels at the treatment of her home country under the dictatorship of Salazar, expressed in the physical force of the bodily expulsion that is the overt subject of the painting. Much of the effectiveness of these paintings stems from a link between the method of the pictures' making and the development of their meaning, a link which becomes clearer as Rego turns to collage as a means of creating pictures. An extension of the physical and often violent, almost destructive pleasure she derived from working with oil paint smeared straight from the tube, Rego's adoption of collage was based on an attitude to form which was as much about cutting up as it was about cutting out:

> *I enjoyed cutting off everything that was protruding – I also liked to make incisions in the bodies and insert things, so there was both passiveness and aggressiveness going on there, sexual stuff. It gives me pleasure, that's why I do it. There's pleasure in hurting things.* (Interview with Tim Marlow, 9 June 2000)

There is also the possibility of revenge. Rego has spoken often about revenge; how one can take the revenge in pictures that one might like to take in real life. Revenge is another fact of life that is often deemed unacceptable, best glossed over in the drive to assimilate all our worst impulses within our conception of ourselves as pleasant, social beings. An acknowledgement of the desire for revenge pulsates throughout Rego's work, both in the way in which she relates to her characters, and in the way they behave towards one another. It is the driving force behind the anti-colonial savagery of *When We Had a House in the Country* 1961, a collage which stated the un-stateable in the public realm, and provided a solution to a pictorial problem posed by *Stray Dogs* 1965. Victor Willing's revelation, in his discussion of the painting in his article 'The Imagiconography of Paula Rego', that it was finished at a time when 'the security of the family was threatened by a girl', unlocks the secret behind some of the picture's determined nastiness. Threat is present throughout the picture, from the heavy form pressing into it from above, to the flies and dogs tormenting each other, and the central character in the foreground. Threat is also converted into revenge in the innate unattractiveness of the heavy form – presumably a representation of the girl – painted, cut up, reassembled and repainted with a sense of horrified fascination at the effectiveness of picture-making as an instrument for behaving in a way that would not be permitted in real life. The artist in fact reveals a great deal more in the painting than her husband in his assessment of it, unpacking some of the emotions surging within his politely cryptic explanatory phrase.

In Rego's later work, narrative becomes more dominant, and the focus on the antisocial shifts away from the activity of the painter and towards that of the characters in the paintings, as the artist explores the often socially unacceptable behaviours which structure how people are (or perhaps how they would like to be). *Cabbage and Potato* 1982 and *Wife Cuts off Red Monkey's Tail* 1981 are pictures in which revenge goes

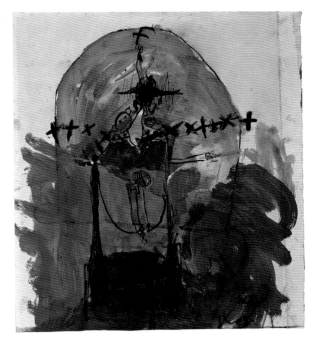

BIRTH 1959 [89]
Oil on paper
32 x 27.5 (12 5/8 x 10 7/8)
Manuela Morais

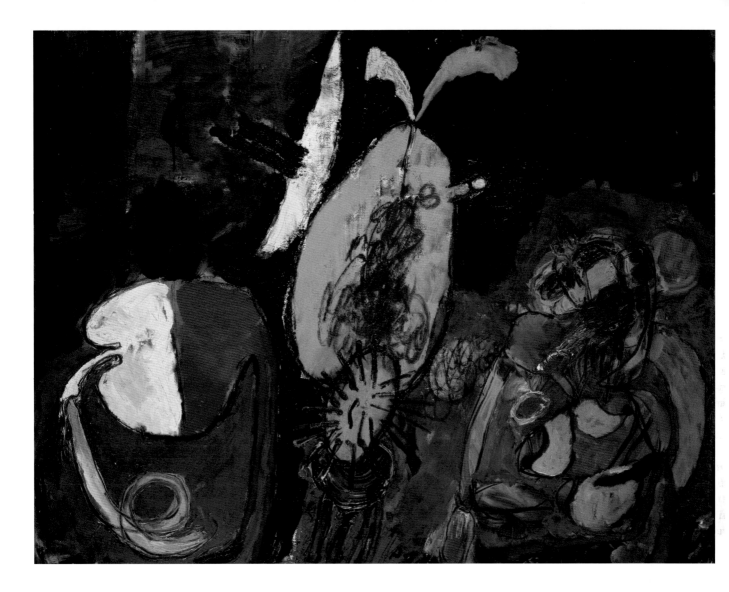

SALAZAR VOMITING THE HOMELAND
1960 [90]
Oil on canvas
94 x 120 (37 x 47 1/4)
Gulbenkian Foundation, Lisbon

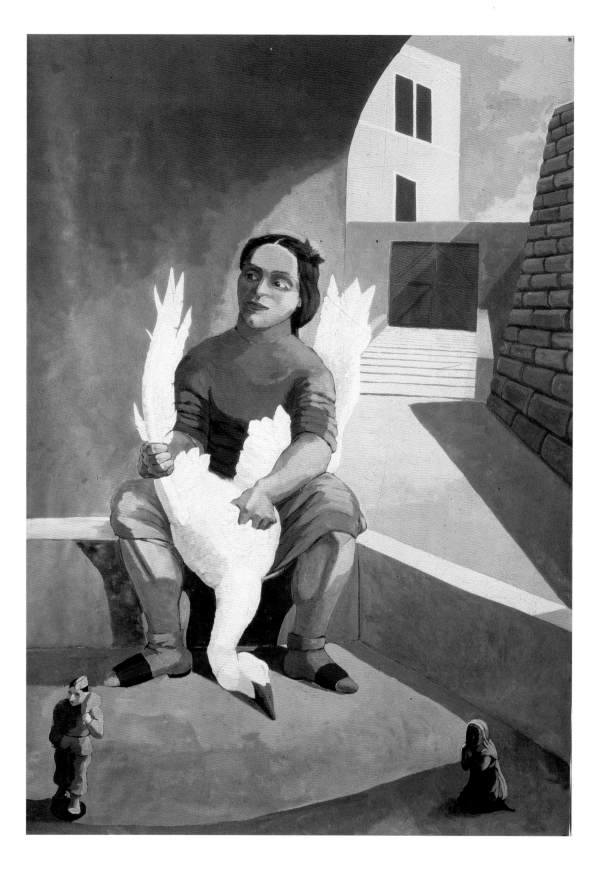

THE SOLDIER'S DAUGHTER 1987 [91]
Acrylic on paper laid on canvas
213.4 x 152.4 (84 x 60)
Private Collection

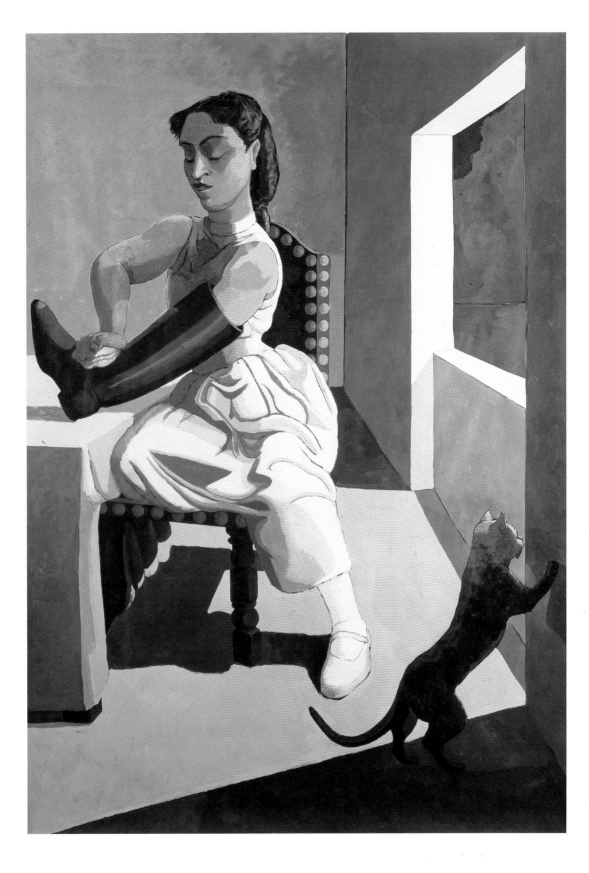

THE POLICEMAN'S DAUGHTER
1987 [92]
Acrylic on paper laid on canvas
213.4 x 152.4 (84 x 60)
Saatchi Collection, London

hand in hand with disgust as two similarly unassimilable emotions. Although these two paintings are much more figurative than the earlier work discussed, the spontaneously expulsive reaction of the red monkey recalls the violent nausea of a work such as *Salazar Vomiting the Homeland* and shares with it an understanding of the working of the forces of the antisocial, albeit now expressed narratively rather than compositionally.

In Rego's later, more figurative work, centred as it frequently is around family relationships, a concern for the antisocial tends to surface in an unabashed confrontation with the ambivalent, often unacceptable behaviour exhibited within close social structures. In the course of her career, Rego has looked closely at almost every possible relationship, both inside and outside the family. Fathers and daughters have been one of her most consistent targets, the relationship coming in for closest scrutiny in the series of family pictures of 1987 and 1988. *The Policeman's Daughter* and *The Soldier's Daughter* (figs.92, 91) both focus on the daughter, her father absent and displaced onto a furiously-polished boot in the one case and a hapless goose in the other. Both girls are trapped – in a house and a courtyard garden – and their relationships with their fathers are obviously not without complications. And somewhat sinister complications at that: the ghosts of Freud stalks *The Soldier's Daughter*. The conjunction of the wide female lap and inverted bird recalling (possibly via Ernst's *The Virgin Spanking the Infant Jesus in Front of Three Witnesses*) Freud's discernment of a vulture concealed within Leonardo's *The Virgin and Child with Saint Anne and Saint John the Baptist* c.1499–1500, which he analysed as a reference to Leonardo's troubled childhood relationship with his parents, particularly his father.

Although both the policeman's daughter and the soldier's daughter carry out the duties that have been assigned to them, cleaning boots and plucking geese, they do so in a way that subverts these activities. In general, Rego's subjects refuse to conform to what might be expected of them, courting ambiguity so that their situations remain mobile, and cannot be resolved according to conventional understanding. Tender embraces are easily confused with violent struggle, as in the complex interaction of the apparently normal bourgeois trio who make up *The Family* 1988. Potentially understanding glances between family members hover close to something voyeuristic and unpleasant, as in the way the father watches the little girl in *The Betrothal* 1999. And *Celestina's House* 2000–1, a study in Portuguese extended family life, is presided over by a matriarch who is clearly a Madam.

Dog Woman is a creature beyond conforming. More lover or mother than daughter, she has taken her behaviour well beyond the bounds of the socially acceptable, and has been caught out. Mouth open, ready to devour, she is all that a woman should not be, and is supremely powerful with it. She looks cornered, and threatened, but manages also to be threatening. Stylistically, she is out of proportion, out of scale – out of line, perhaps. *Dog Woman* contains within her many of the versions of the female subject that come before and after her in Rego's work: the girls in *Looking Back* 1987 who have taken things into their own hands, the unrepentant hunters in *Scavengers* 1994, the wronged red monkey's wife, hell-bent on revenge at its most anti-social. She also, crucially, looks forward to the old women of the artist's most recent work.

For the cover of the exhibition catalogue accompanying her latest exhibition, at Abbot Hall Art Gallery

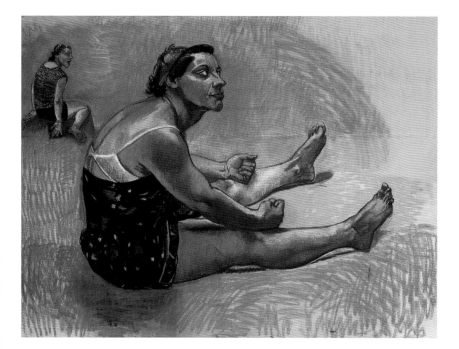

WAITING FOR FOOD 1994 [93]
Pastel on canvas
120 x 160cm (47 1/4 x 63)
Private Collection

GRANDMOTHER 2000 [94]
Hand-coloured lithograph
76.5 x 56 (30 1/8 x 22)

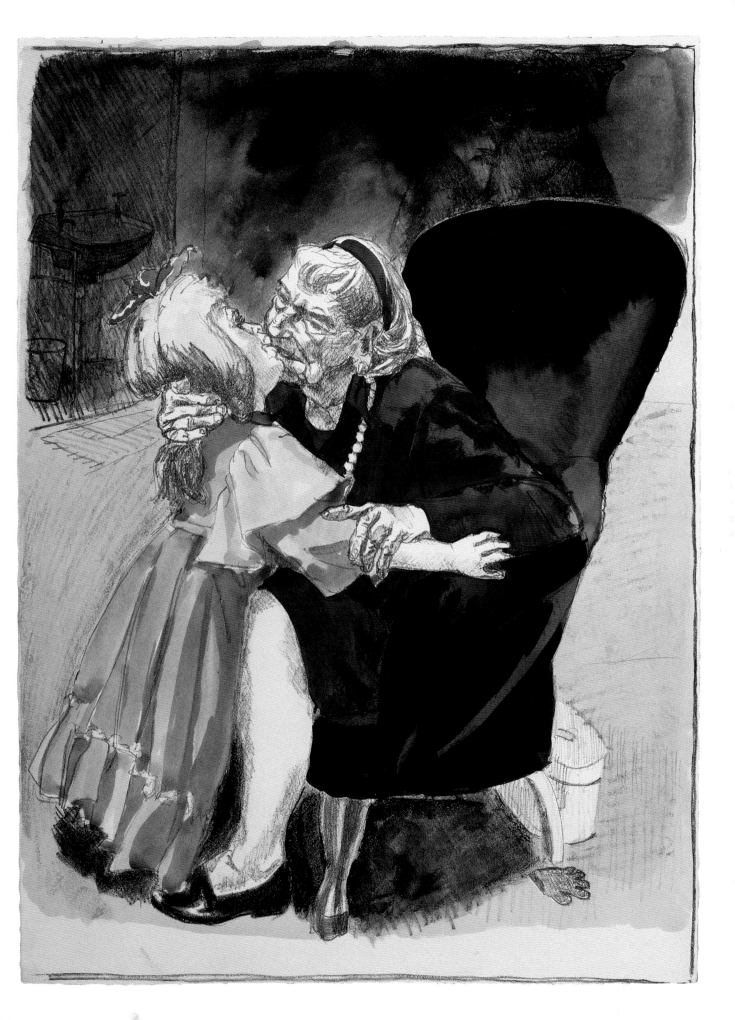

in Kendal, Rego chose to use a detail from the large drawing *The Wide Sargasso Sea* 2000 (fig.85). The detail shows the old woman who provided the artist with a way in to the story of Celestina, around which most of the work in the exhibition turned. On her own, the nude old woman strikes a blow against the forces of conformity. Old naked flesh is not something we generally expect to see, although we must accept that it is an inevitable part of life, and our own life at that. The old woman is worked swiftly in pastel, drawn in tones of pink and red that recall *Gluttony* and *Birth*, and with a visceral pleasure in unvarnished physical truth that is also present in those early pictures. The old woman's body sags and bulges as she lies collapsed on the floor, but her mind is clearly intact, and she looks up out of the frame of the detail, not in desperation, but with a certain speculation.

In the larger picture, she is looking at a little girl – perhaps her daughter or grand-daughter or even an early version of herself. In this work is focused a whole series of pictures of old women and young girls which Rego completed at the same time. Like something out of *Little Red Riding Hood*, these old women are simultaneously grandmother and wolf as they contemplate their little girls, looking at themselves in the mirrors the girls unwittingly hold up and in which, we may be sure, they also see themselves

reflected. The old women are, like *Dog Woman*, beyond conforming, and are edging their way literally out of society. The series is a study in relationships on the brink, not so much of what society finds acceptable, but of what an individual can bear. All the ambiguities and ambivalences that both structure and threaten a woman's relationship with her mother as each grows older are there in these pictures, from the blood-sucking kiss of *Grandmother* (fig.94) to the twin drives for protection and rejection in *A Girl with Two Mothers*. Sometimes the old women have the upper hand, and sometimes, as in the guilt-riven *Nursing* or *Don't Leave Me*, their frail physical presence falls far short of the powerful hold they still have on their daughters' imagination. A triumph of antisocial, conventionally unacceptable behaviour, the series confronts its characters' expectations of themselves as well as those that society places on them, providing a space in which to think the unthinkable – disgust, revulsion, fear – and to link these inextricably to love.

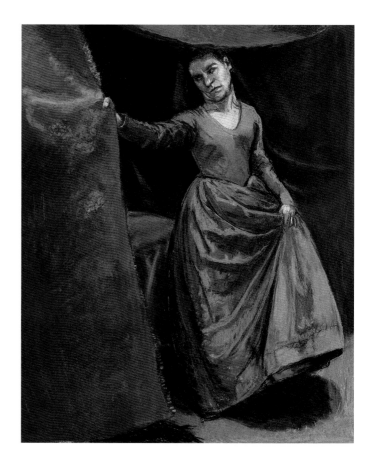

from left to right [95]:
JANE; EDWARD; BERTHA'S MONKEY
2002
Pastel on paper mounted on
aluminium
left panel 120 x 100 (47 1/4 x 39 3/8)
centre panel 100 x 80 (39 3/8 x 31 1/2)
right panel 120 x 100 (47 1/4 x 39 3/8)
Marlborough Fine Art, London

Biography

Solo Exhibitions

Centre, Nicosia, Cyprus; travelling to Town Hall, Larnaca, Cyprus
Ainscough Gallery, London

1998 *Paula Rego: Pendle Witches and Peter Pan*, Midland Art Centre, Birmingham
Paula Rego – The Sins of Father Amaro, Dulwich Picture Gallery, London. Cat. text by Desmond Shawe-Taylor.
Paula Rego – Pra Lá et Pra Cá, Galerie III, Lisbon
Paula Rego – Pendle Witches, Harris Museum and Art Gallery, Preston

1998 *Pendle Witches*, Galería Marlborough, S.A., Madrid

1999 *Paula Rego – The Children's Crusade – a suite of 12 etchings*, Marlborough Graphics, London
Paula Rego – Recent Work, Galería Marlborough, S.A., Madrid
Paula Rego, Fundação Calouste Gulbenkian, Lisbon
Open Secrets – Drawings and Etchings by Paula Rego, University Art Gallery, University of Massachusetts, Dartmouth, USA; Centre Culturel Calouste Gulbenkian, Paris
Children's Crusade, Edinburgh Printmakers Workshop
Nursery Rhymes, White Gallery, Brighton

2000 *Paula Rego, Pendle Witches, Children's Crusade and Drawings*, Abbot Hall Art Gallery, Kendal

2001–2 *Celestina's House*, Abbot Hall Art Gallery, Kendal; travelling to Yale Center for British Art, New Haven. Cat. text by Fiona Bradley.

Selected Group Exhibitions

1955 Young Contemporaries, London
1961 *Segunda Exposição de Artes Plásticas*, Fundação Calouste Gulbenkian, Lisbon
1965 *Six Artists*, Institute of Contemporary Arts, London
1967 Bienal de Tokyo, Japan
Novas Iconologias, Lisbon
Art Portugais – Peinture et sculpture de Naturalisme à nos jours, Brussels; Paris; Madrid
1969 XI Bienal de São Paulo, Brazil (representing Portugal)
Gravure Portugaise Contemporaine, Paris
1970 *Novos Sintomas na pintura portuguesa*, Galeria Judite Dacruz, Lisbon
1973 *Pintura portuguesa de hoje-abstractos e Neo-figurativos*, Lisbon; Salamanca; Barcelona

26 Artistas de Hoje, Lisbon
Exposição de Artistas Modernas Portugueses, Galleria Quadrum, Lisbon
1974 Expo AICA, Sociedad Nacional de Belas Artes, Lisbon
1975 XIII Bienal de São Paulo, Brazil
Figuraçao Hoje, Lisbon
1976 *Arte Portugués Contemporanea*, Galerie Nazionale d'Arte Moderna, Rome
Art Portugais Contemporain, Musée d'Art Contemporain de la Ville de Paris
Exposiçao de Arte Moderna Portuguesa, Sociedad Nacional de Belas Artes, Lisbon
1977 *Artistas Portugueses en Madrid – Pintura e Escultura Contemporaneas*, Madrid
1978 *Portuguese Art since 1910*, Royal Academy of Art, London
Exposição individual, Galeria III, Lisbon
1979 *Femina*, UNESCO, Paris
1981 *Artists in Camden*, Camden Arts Centre, London
Ante-visão do Centro de Arte Moderna, Fundação Calouste Gulbenkian, Lisbon
The Subjective Eye, Midland Group, Nottingham
1982 *Three Women*, Edward Totah Gallery, London
Inner Worlds, Midland Group, Nottingham
Pintura portuguesa contemporanea, Museu Luis de Camões, Macau
Hayward Annual, Hayward Gallery, London
John Moores Exhibition of Contemporary Painting, The Walker Art Gallery, Liverpool
1983 III Biennale of Graphic Arts, Baden-Baden
Eight in the Eighties, New York
Marathon 83, New York
1984 *1984 – an exhibition,* Camden Arts Centre, London
Os Novos Primitivos, Cooperative Arvore, Oporto
1985 *The British Art Show*, Ikon Gallery, Birmingham
Diálogo sobre arte contemporanea, Centro de Arte Moderna; Fundação Calouste Gulbenkian, Lisbon
IX Biennale de Paris, France
Animals, Edward Totah Gallery, London
Exposição Diálogo, Fundação Calouste Gulbenkian, Lisbon
John Moores Exhibition of Contemporary Painting, The Walker Art Gallery, Liverpool
XVIII Bienal de São Paulo, Brazil (representing Britain)

Passion and Power, La Mama and Gracie Mansion, New York
1986 *A primeira década*, Módulo-Centro Difusor da Arte, Lisbon
Le XXéme au Portugal, Centre Albert Borchette, Brussels
Teira Exposiçao de Artes Plásticas, Fundação Calouste Gulbenkian, Lisbon
AICA-PHILAE, Sociedad Nacional de Belas Artes, Lisbon
Love Sacred and Profane, Plymouth
The Human Zoo, Nottingham Castle Museum, Nottingham
Contemporary British and Malaysian Art, National Gallery, Kuala Lumpur
Nove – Nine Portuguese Painters, John Hansard Gallery, Southampton
1987 *Art Contemporáneo Portugués*, Madrid
Current Affairs – British Painting and Sculpture in the 1980s, Museum of Modern Art, Oxford; travelling to Hungary, Poland, Czechoslovakia
70 – 80: Arte Portuguesa, Brasilia, São Paulo, Rio de Janeiro
Alberto da Lacerdo – O Mundo de un poeta, Fundação Calouste Gulbenkian, Lisbon
30 Obras de Arte Uniao de Bancos Portugeses, Case de Serralves, Oporto
Feira do Circo, Forum Picoas, Lisbon
Exposição Amadeo Souza-Cardoso, Casa de Serralves, Oporto
Obras de uma Colecçao Particular, Casa de Serralves, Oporto
1988 *Works on Paper by Contemporary Artists*, Marlborough Fine Art, London
35 Pinturas de Colecçao do Banco Portugues do Atlantico, Casa de Serralves, Oporto
Cries and Whispers, British Council travelling exhibition, Australia
Narrative paintings, Castlefield Gallery, Manchester
Objects and Image, Aspects of British Art in the 1980s, Stoke-on-Trent Art Gallery
1989 *Ines de Castro*, Richard Demarco Gallery, Edinburgh
1989–90 *Picturing People: Figurative Art in Britain 1945–1989*, British Council travelling exhibition: National Gallery, Kuala Lumpur; Hong Kong Museum of Art; National Gallery of Zimbabwe, Harare
1990 *Now for the Future*, Hayward Gallery, London; Mappin Art Gallery, Sheffield
1990–1 *British Art Now: A Subjective View*, British Council travelling exhibition, Japan
The Great British Art Exhibition, Glasgow

1991 XI International Print Biennale, Bradford

1991 *Modern Painters – A Memorial Exhibition for Peter Fuller*, City Art Galleries, Manchester

Triptico, Museum van Hedendaagse Kunst, Ghent

1991–2 *From Bacon to Now – The Outsider in British Figuration*, Palazzo Vecchio, Florence

The Primacy of Drawing – An Artist's View, South Bank Centre travelling exhibition: Bristol Museum and Art Gallery; Stoke-on-Trent Art Gallery; Graves Art Gallery, Sheffield

1992 *Myth, Dream and Fable*, Angel Row Gallery, Nottingham

1992–3 *Innocence and Experience*, Manchester City Art Galleries and South Bank Centre travelling exhibition: Ferens Art Gallery, Hull; Castle Museum, Nottingham; Kelvingrove Art Gallery and Museum, Glasgow

1992–3 *Life into Paint: British Figurative Painting of the 20th Century*, Israel Museum, Jerusalem

1993–4 *Writing on the Wall – Women Writers on Women Artists*, Tate Gallery, London; travelling to Norwich Castle Museum; Arnolfini Gallery, Bristol

1994 *Unbound – Possibilities in Painting*, Hayward Gallery, London

Waves of Influence (Nursery Rhymes and Peter Pan graphics), Snug Harbour Cultural Center, Statton Island, New York

Here and Now, Serpentine Gallery, London

John Murphy, Avis Newman, Paula Rego, The Saatchi Gallery, London

1994–5 *An American Passion – the Summer Collection of Contemporary British Painting*, The McLellan Galleries, Glasgow; The Royal College of Art, London

1995 *Open Studio*, The Florence Trust, London

Summer Exhibition, Marlborough Fine Art, London

Peep, Brighton Museum in collaboration with the Institute of International Visual Art

New Acquisitions, National Portrait Gallery, London

1996 *David Hockney: Six Fairy Tales from the Brothers Grimm; Paula Rego: Nursery Rhymes*, University Museum, Long Beach, California

Spellbound: Art and Film, Hayward Gallery, London

1998 *Lyrical Orientations – The Poetic in Art*, Beatrice Royal Contemporary Art & Craft Gallery, Eastleigh, Hampshire

Artaid '98, Edinburgh City Art Centre

Lines of Desire – an international drawing exhibition, Bluecoat Gallery, Liverpool

From the Interior, Aberystwyth Arts Centre, Aberystwyth

1998–9 *The School of London – from Bacon to Bevan*, Musée Maillol, Paris; Auditorio de Galicia, Santiago de Compostela; Kunst Haus, Vienna

1999 *Portrait of a City – Seven Figurative Painters from London*, John Berggruen Gallery, San Francisco

Watercolour C21, Bankside Gallery, London

Figuration, Ursula Blickle Stiftung, Bruchsal, Germany; Rupertinum Museum, Salzburg, Austria; Museion, Bolzano, Italy

Lines of Desire, Pitshanger Manor Gallery, London

2000 *Elogio de lo Visible*, International Figuration Exhibition, Galería Marlborough, S.A., Madrid; travelling to Centro Cultural Las Claras, Murcia; Centro Cultural Casa del Cordon, Burgos; Cultural Rioja, Logrono

Pastel Society Centenary Exhibition, Mall Galleries, London

Culturgest, Lisbon

Carnivalesque, Hayward Gallery travelling exhibition: Brighton Museum; Nottingham Castle Museum

James Gleeson – Recent Paintings; Paula Rego – The Children's Crusade 1996–98 & Untitled 1998–99, Charles Nodrum Gallery, Melbourne, Australia

Encounters: New Art from Old, The National Gallery, London

2000–1 *British Art Show 5*, Hayward Gallery travelling exhibition: Scottish National Gallery of Modern Art, Edinburgh; Southampton City Art Gallery; National Museum of Wales, Cardiff; Birmingham Museum & Art Gallery

The School of London and their Friends The Collection of Elaine and Melvin Merians, Yale Center for British Art, New Haven; Neuberger Museum of Art, Purchase NY, USA

Selected Books and Articles

1974 José Augusto França, *Pintura portuguesa no século XX*, Lisbon 1974

1984 Rui Mário Gonçalves, *Pintura e escultura em Portugal, 1940 – 1980*, Lisbon 1984

1986 Alexandre Melo and Joao Pinharanda, *Arte Contemporânea Portuguesa*, Lisbon 1986

Bernardo Pinto de Almeida, *Breve introdução à pintura portuguesa no século XX*, Oporto 1986

1989 *Nursery Rhymes*, London 1989

1991 Hector Obalk, *Paula Rego*, Kyoto 1991

1992 John McEwen, *Paula Rego*, London 1992, 1997

1993 *The Art Book*, London 1993

Peter Pan, London 1993

1994 Marina Warner, *Wonder Tales*, London 1994

A Portfolio – Nine London Birds, London 1994

1995 Diana Eccles and Barbara Putt (eds.), *British Council Collection Catalogue*, vol.2, London 1995

1996 Blake Morrison, *Pendle Witches*, London 1996

John McEwen, *Dancing Ostriches*, London 1996

1997 Colin Wiggins, 'Paula Rego', in Delia Gaze (ed.), *Dictionary of Women Artists*, vol.1, London 1997, pp.1155–9

1998 Frances Borzello, *Seeing Ourselves – Women's Self-Portraits*, London 1998, pp.26, 177 and 214

Alexandre Melo, *Artes Plàsticas em Portugal, Dos Anos 70 aos nossos Dias*, Portugal 1998, pp.28–31 and 104–7

1999 Elizabeth Cayzer, *Changing Perceptions – Milestones in Twentieth-Century British Portraiture*, Brighton 1999, pp.87–91

Marco Livingstone, *Paula Rego – Grooming*, in Maria Vaizey (ed.), *Art: The Critics' Choice*, New York and London 1999

Elizabeth Drury, *Self Portraits of the World's Greatest Painters*, London 1999, p.306

2000 Andrew Graham-Dixon, 'The Art of Success, Portraits by Snowdon', Vogue, May 2000

Chris Dunn, *People Looking at Art*, London 2000

Copyright credits

Photographic credits

Index